ART *of* DRAWING

THE HUMAN BODY

Sterling Publishing Co., Inc.

NEW YORK

Translated from the Spanish by Edgar Loy Fankbonner

Library of Congress Cataloging-in-Publication Data Available

10 9 8 7 6 5 4 3 2 1

Published in 2004 by Sterling Publishing Co., Inc.
387 Park Avenue South, New York, NY 10016
Originally published in Spain in 2003 under the title *Dibujo de Figura* Humana by
Parramon Ediciones, S.A., Barcelona, Spain
Copyright © 2003 by Parramon Ediciones, S.A.
English translation copyright © 2004 by Sterling Publishing Co., Inc.
Distributed in Canada by Sterling Publishing
^c/o Canadian Manda Group
One Atlantic Avenue, Suite 105
Toronto, Ontario, Canada M6K 3E7

Distributed in Great Britain by Chrysalis Books
64 Brewery Road, London, England N7 9NT

Distributed in Australia by Capricorn Link (Australia) Pty Ltd.
P.O. Box 704, Windsor, Australia NSW 2756

Printed in Spain
All rights reserved

Sterling ISBN: 1-4027-1148-4

ART
of
DRAWING
THE HUMAN BODY

Contents

III ATTITUDES OF THE HUMAN FIGURE: THE POSE 60

IV LIGHT AND SHADOW IN THE HUMAN FIGURE 82

V TEXTURES AND EFFECTS 106

VI STEP BY STEP 126

Introduction

The FIGURE
AS ARTIST'S OBJECTIVE

The popularity that drawing the human figure has achieved over the course of history is reason enough to attract the artist to its practice. Drawing with the perfection that we observe in the great masters is a seemingly difficult task, for there are technical challenges in drawing the human figure that are absent with other subjects. This compels us to put into practice everything we know about drawing in order to adequately solve such problems as the proportion of the limbs in relation to the whole body and the representation of volume, joints, and muscle tone. Drawing the human body presents a greater challenge than any other subject, because both artist and viewer are intimately familiar with the body's proportions and the physiology of the human figure. Here, even a small mistake in drawing becomes evident. For this reason, an artist who can masterfully draw landscapes, still lives, or interiors may make mistakes when drawing the human figure. We often find the artist exaggerating depth and forms—which cannot always be read as a product of his particular interpretation, but of the need to disguise shortcomings and inexperience in drawings of this nature.

Drawing the human figure requires a curious gaze and a will to keep practicing even if our first drawings fail. Observing and drawing the human figure regularly allows us to adjust our visual memory to physical forms, body language, and facial expressions in different situations.

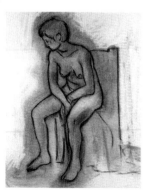

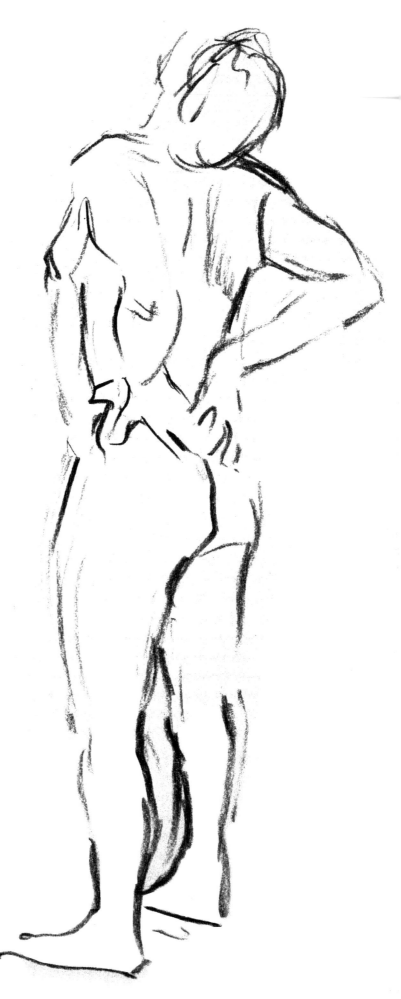

We will show in this book that drawing the human body need not be so difficult. Starting from a simple base and applying a series of tricks and techniques, the reader will find himself able to adequately render a nude figure. The nude is to be considered an ideal model for a full study of forms and light. For this reason, when drawing a nude body, it is important to study the model's anatomy, and also the lighting, because lighting plays a role in making the sense of depth and relief more—or less—prominent.

Practicing this kind of drawing sharpens visual perception at the same time that it exercises our ability to depict forms. The human figure is a highly suggestive and evocative subject, which can be approached from many different perspectives and individual styles without diluting its essence. From an academic point of view, drawing the nude is the best form of discipline because it forces the artist to pay attention to proportion and teaches the skillful calculation of organically coordinated forms and sizes; from an interpretive point of view, it allows us to give free rein to form and contour.

STUDY OF THE

Nude Figure

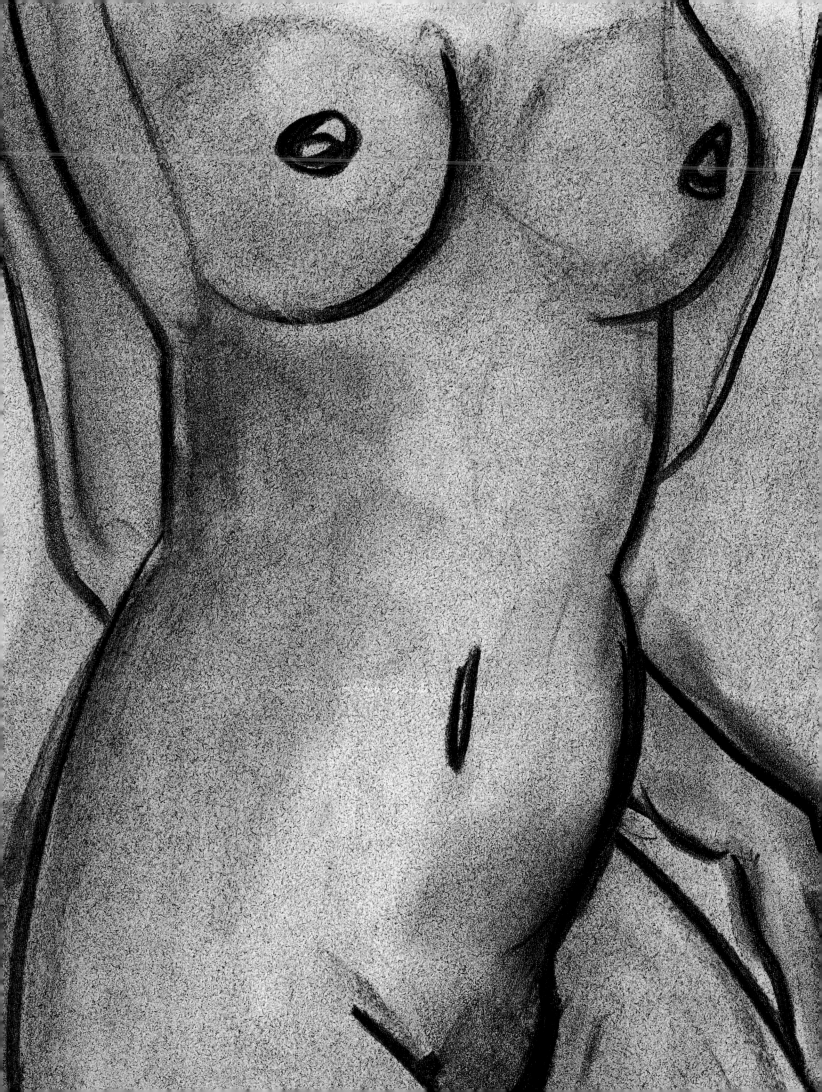

The Body
AND ITS

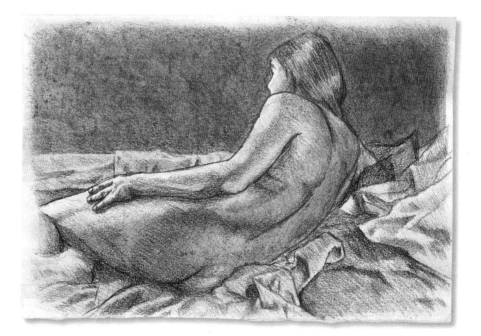

Marta Bru. *Nude*, 2002.
Charcoal and black chalk.

PROPORTIONS

In order to properly introduce the study of the human figure, let us set forth a few general guidelines that will allow us to draw any figure, using a system of proportions that can be adjusted to the view we have at any given moment. Proportion is the equilibrium of measurements that establish harmony among objects—in this case, among the parts of the human body. Although today artistic license allows the drawing of figures with specific stylistic quirks, it will be easier for the novice to begin by following a set of rules that will help him to draw a well-proportioned figure.

PROBLEMS *in* DRAWING
the HUMAN FIGURE

In any given era, learning to draw the human figure, whether nude or clothed, is perhaps the foremost goal of any painter. The nude is the most beautiful and complex of subjects, and is often considered the artist's greatest challenge. Although drawing the nude figure is widely considered to be very difficult, it is in fact generally easier than than a portrait, because it does not require that the artist focus on facial details.

Figural Problems
Drawing the human body requires the artist to gather all of her skills in working with real form and volume. As a subject, the human figure requires that we put into practice an entire set of representational skills as we arrange the limbs in a proportional relationship to the body; it also requires the representation of volumes, articulations, planes, and simple forms and their combination into more complex ones. Once we can accurately render the human figure, it is safe to say that we can also take on any other subject, no matter how complicated it may appear.

Synthesis, or reducing forms to their essential content, is a key factor in drawing correctly.

In order to understand the figure, it is first necessary to understand its inner structure. We must observe and infer what is hidden underneath every pose.

By combining synthesis with spontaneity, we achieve a more expressive figure.

The Secret of Simple Forms

Here's a strategy for approaching the challenges of representing the human figure: first, figure out a starting point for the figure based on simple forms that adjust to the contours of the body (we will see this in the following chapters); then, work with these forms until you arrive at a convincing and recognizable structure. From there, the proportions must be carefully established, making sure that the figure has a proper equilibrium; this is especially important when drawing standing figures. Don't be discouraged by your first drawings, which will most likely look like crudely made dolls—a jumble of sketchy, ill-fitting forms. The best way to start is to reduce complex forms into simpler ones.

A drawing of the human figure should start with an oval representing the head, and then a vertical line for the body. We then add the thorax and the line of the hips, which connects the upper and lower extremities.

Starting from a simple outline, we can make a geometric sketch of the human body.

BASIC HUMAN PROPORTIONS

A drawing is considered ill-proportioned when the figure's head appears larger than normal, or when the arms seem too long or too short—in other words, when the figure deviates from what we consider normal. To avoid disproportionality, we look to the laws of proportion as represented in an idealized, conventional drawing of the human form, in other words, one which possesses a perfect relationship between the body's measures. The way we represent the human figure today is based on a Greco-Roman model, the classical Greek law of proportion, which was adopted by the Romans and later resurfaced during the Renaissance after centuries of disuse.

Body Height

The law of proportion for the human figure is based on a unit of measurement that corresponds precisely to the measurements of the head. According to the classical laws of proportion, the total height of the human body should be equal to seven and a half heads, or seven and a half units. Praxiteles's law established a new idealization of the human body: according to this model, the total height of the human body must equal eight heads. In the early twentieth century, scientific analysis set the proper height of the human body at eight and a half heads. All of these models are valid, but for our purposes, we will use the measurement of eight heads to simplify our study of the academic figure.

The law of proportion based on eight heads yields a proportionate representation of the human body. The division of the body into units serves as a reference for correctly distributing each element of the body.

Often, artists will use a law of proportion based on ten heads for the human body, suggesting a more stylized, elongated figure with a more expressionistic character.

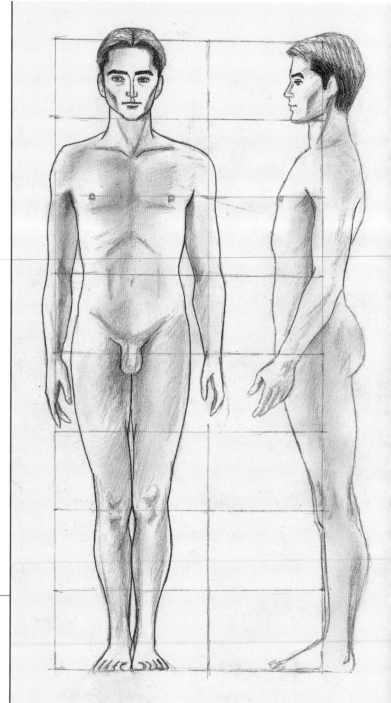

Matching Units

A law of proportion based on units is useful primarily because it allows you to compare the relationship between the extremities by referring to the divisions between the units.

In a proportional model, the figure will be eight units tall and two units wide. Each unit is equal to the length of the head. The nipples coincide with unit number two. The armpits also coincide with the borderline between the second and third units; and the navel is located in unit number four. Unit number four also marks the position of the elbows, and is a fairly precise mark for the height of the waist. The hand is as long as the face, and the knee is located slightly above the sixth unit. The knees are located in the dividing line between the sixth and seventh units.

The unit system also lets us reference other significant points that are of great help in understanding anatomy and facilitating the representation of the figure; they are also a useful width reference when we need to check the more important demarcations.

The size of the head and the rest of the distances between parts of the body can be measured with a pencil. Then, we simply transfer those proportions onto the paper, especially the measurements for the height and width of the body (which, as you may recall, should equal two heads).

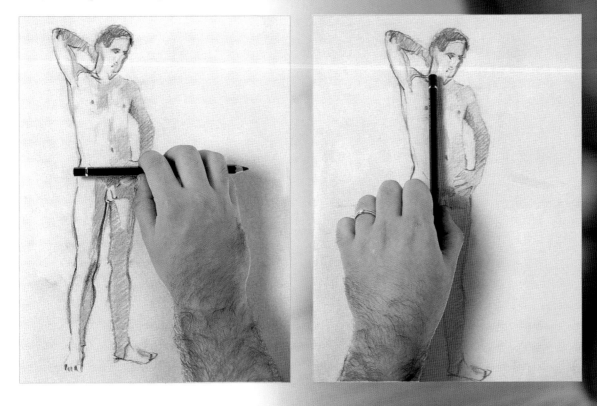

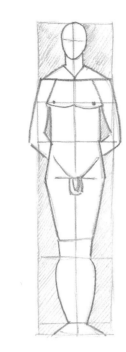

The same imaginary line that divides the frontal view of the body into two halves can also be seen in the rear view of the body. The line is more visible in the rear view thanks to the ridge of the spine.

The Back

When a figure is pictured from the back, the first feature that we notice is the clear definition of the figure's vertical axis. The line marking the vertical axis is accentuated by the backbone, by the ridge that the spine forms, by the separation of the buttocks, and by the line describing the inside of the legs.

The Outline of the Body

The outline that marks the limits of the body is described by the muscular reliefs of the body. Muscles are fleshy masses that mold the body, made up of a special tissue that has the property of contracting and changing shape when the figure performs an action. The forms we appreciate on the surface of the body result from the volume of all the muscle masses, including the deepest ones, but the ones closest to the surface are of greater interest to the artist.

The line that marks the spine should be drawn as the axis of symmetry; this way, it will serve as a reference for placing the parts of the body on either half of the body.

The curve that describes the spine, and the extension of this line down to the feet, is a guide for capturing the figure's gesture as viewed from the rear.

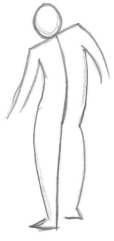

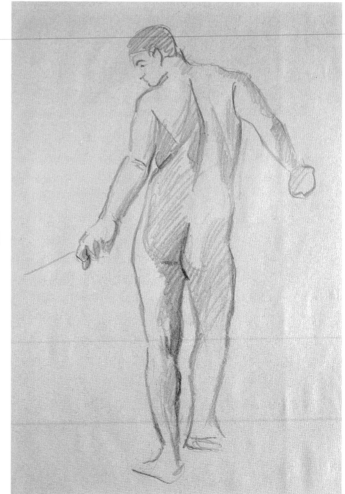

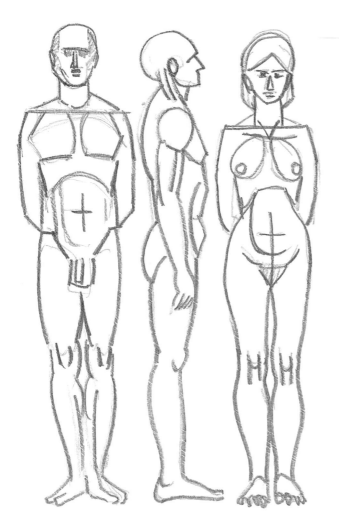

The shape of the body is defined by the bone structure and the layer of muscle covering it. The muscle is what gives the body its contours. Like the other parts of the body, the shape of the muscles can also be broken down and sketched geometrically.

When drawing a standing figure, the weight of the body should be properly distributed. To distribute the weight correctly, keep the line of the neck, the hips, and the feet aligned, no matter how much the body twists.

All muscles are paired and symmetrical, but a woman's muscles are less pronounced, which softens the contours of her body.

Muscle Pairs

When drawing the volume of the body, it is important to remember that every muscle belongs to a pair. If you draw a figure from the front, the muscles should be symmetrical. Another important thing to remember is that the muscles in the extremities are long and overlapping, while muscles in the torso are flat and expansive. Even though a woman's musculature is essentially the same as a man's, the female body has a layer of subcutaneous fat that softens the external form. For this reason, the male body will always display a more pronounced, voluminous musculature.

PROPORTIONS *of the*
FEMALE FIGURE

The proportions of the male
and female body are not
much different. The main
anatomical difference lies in the
female body's narrower shoulders
and wider hips.

The chest is slightly lower in
the female body than in the male.
Like the male's, the female's waist
is located on the dividing line
between the third and fourth
units, although a woman's waist is
narrower and closer to the chest
than a man's. Viewed from the
side, the arch of the back is more
pronounced than a man's, and as a
result, the buttocks appear more
prominent. One of the most
important factors in making a a
good drawing of the female figure
is placing the waist at the right
height, somewhat lower than a
man's; this is one of the
anatomical features that gives the
female body its characteristic
form.

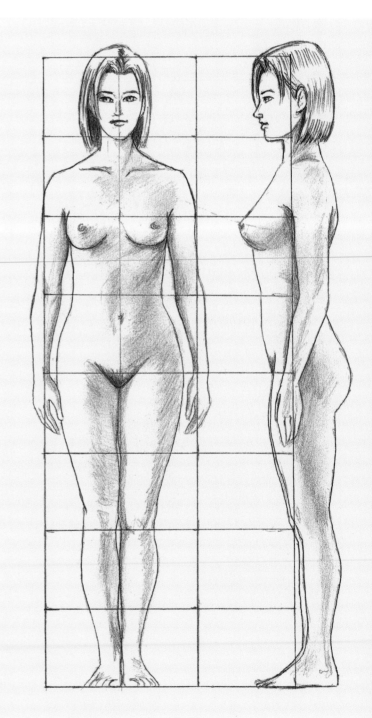

*Despite the differences between the male
and female anatomy, they both follow the
eight-head law of proportion, although the
configuration of the female's anatomical relief
is noticeably different from the male's.*

The Outline, Back and Front

The female outline is softer than the male in its transitions between one area and another. The buttocks protrude beyond the vertical line marked by the shoulders, and the outline of the legs describes a diagonal that is less pronounced than the male's. Viewed from behind, the most outstanding characteristic of the female form is the clear contour of the back and hips, which is clearly defined by the waist. The relief of the female torso is far less dictated by the shape of the muscles.

The Female Head

There are several features that clearly distinguish the female head from the male. A man's head is usually more angular than a woman's, which is generally rounder. The bone structure, especially the frontal bone, is more pronounced in a man's face; a woman's profile has softer features, an oval face, and a more bulbous forehead. Furthermore, a man's neck is robust, while a woman's is more delicate.

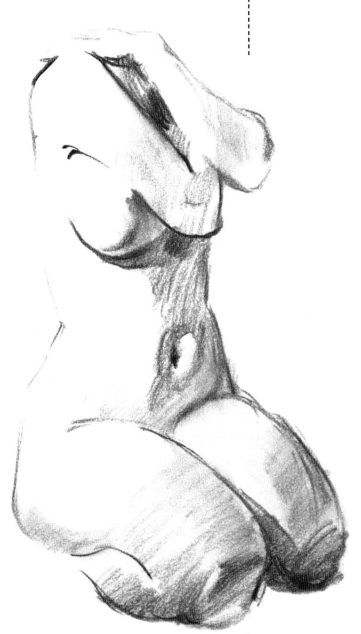

Drawing from oval shapes is useful in establishing the main features of the female body, and is an important skill to practice.

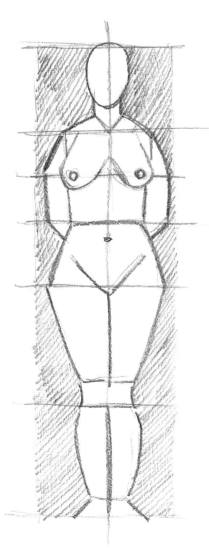

Drawing the female form based on geometric schemes makes it easier to determine the size and position of each part of the body.

A layer of subcutaneous fat gives the female body voluptuous, rounded forms dominated by curves and a sinewy outline.

The law of proportion is important for drawing children, but it is less reliable than it is for adult figures. During childhood the body is constantly evolving, and anatomical proportions change a great deal in a short period of time.

The CHILD
MODEL

A baby's body features very rounded forms that show the folds of every joint.

A child's head begins with two ovals, one for the upper skull, and another for the jaw and cheeks.

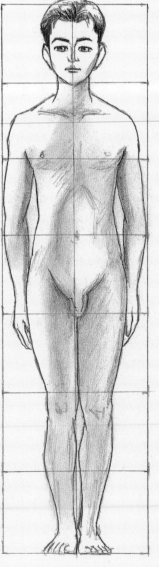

Basic Proportions

One of the basic differences between a child's body and that of an adult is the head: a child's head is much more voluminous compared to the rest of his body. This feature is attenuated as the body grows. In general, a newborn's height is only three times the size of his head. When the child is approximately one year old, the total length of his body is three and a half times the length of his head. Compared to the head and the torso, his legs are relatively short. At four years, the head is still very large in proportion to the rest of the body, but because the child is taller, his body now comprises five units. At twelve, the child's total height is seven times the length of his head, and the middle of his body descends toward the hips.

The law of proportion is important when drawing child figures, but it is less reliable than it is for the figure of an adult, due to the great differences in proportions that occur during growth.

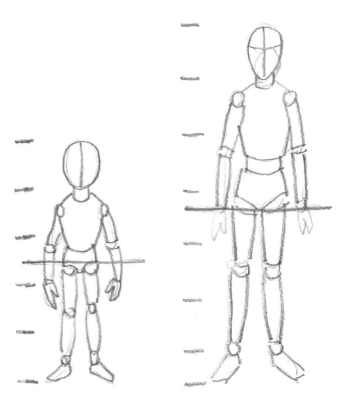

As the child's body develops, the middle of the body descends. The middle of a baby's body is located at the navel, whereas the middle of a twelve-year-old's body is slightly above the pubic area.

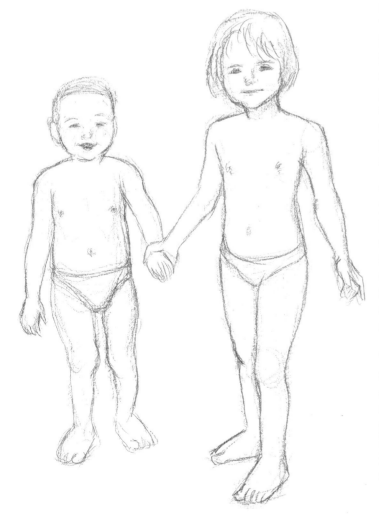

Children's Forms

When attempting to draw a child figure, be aware of its rounded forms, and avoid sharp, angular lines. It's better to magnify the wavelike motions of the child's contours than to worry too much about getting the perfect proportions. Children are in a process of anatomical development, so it is useless to try to represent the shape of their bodies with the same precision that you would with an adult figure, male or female.

The Middle of the Body

If you draw a horizontal line down the middle of a body from childhood through adulthood, you'll see clearly how the middle of the body moves downward from the stomach. At eight years, the middle lies somewhere above the hips. The head changes very slightly, while the arms and legs grow longer. The drift of the middle of the body is basically the result of the growth of the legs during adolescence.

The Trouble with Live Models

Child models present several special problems for the artist, not the least of which is the fact that children—especially small children—can never stay put for long. So it is necessary to take frequent breaks, keep them entertained with toys or other items, and make sure that they assume the pose that is most comfortable for them.

ELDERLY *and* OBESE
FIGURES

The shape of the human body depends a great deal on its structure, so when you try to draw a figure correctly, it is essential to understand your model's anatomical features and physical complexion, which are specific to their age and body type, in order to personalize the figure.

The Elderly Model

The body of an elderly person is distinctly different from the proportions of an adult figure. The forehead is more ample as a result of hair loss, bags appear under the eyes, the skin is less taut than before, the chest appears to sag, the limbs are flaccid, and the bone structure is more visible. Very little muscle mass remains, so the shape of the body is determined entirely by the skeleton. As a person grows old, his skin loses its elasticity and begins to sink, giving the impression that the bones are closer to the surface.

The skin's wrinkled, flaccid texture crates shadows in the model, which you can draw by using gray hatching.

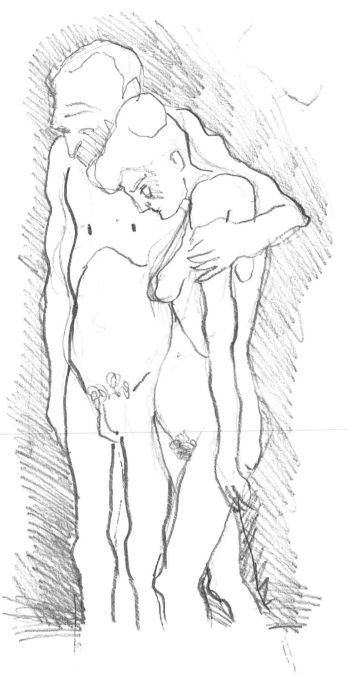

In old age, the muscles become flaccid and the bone structure more evident. The body hunches over and shows incipient deformities.

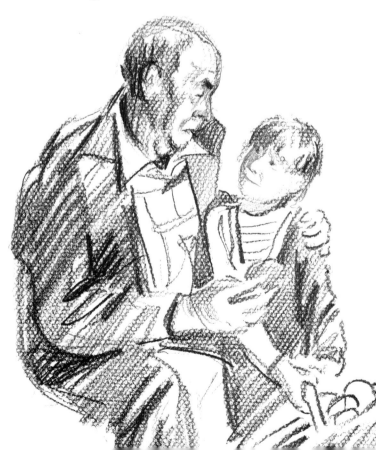

The face is where old age is most readily visible, so it is important to pay special attention to its features. The bulky clothes worn by the elderly disguise the transformation of their anatomy.

The shape of the body is noticeably modified when fat accumulates in the bosom, stomach, buttocks, and thighs. When drawing an obese figure, the best thing to do is to start with a sketch based on oval shapes.

Obese Figures

There is a layer of fat between the muscles and the skin that fills in the gaps and softens the shape of the bones. The fat is barely visible in the body of an athletic person, because it adds only slightly to the person's girth; but in an obese person, it can amount to as much as five or six inches, so it plays an essential role in shaping the volume and girth of the body.

This layer of fat is not evenly distributed throughout the body. In men, it is generally concentrated in the chest, accentuating the profile of the cleft just below the pectoral area; in the area below the chin; in the stomach; and in the buttocks. In women, fat tends to affect the shape of the breasts (which grow disproportionately and look more flaccid), the chin, the stomach, the thighs, and especially the area around the pelvis and up to the end of the gluteus muscles. For this reason, the part of the body that stands out most in an obese woman is the exaggerated width of the hips and the large behind. The other parts of the body tend to look more cylindrical, and the folds around the joints are more pronounced because the flesh there is fattier. The same thing happens with the person's facial features, which tend to swell generally; body fat is particularly visible in the cheeks and chin.

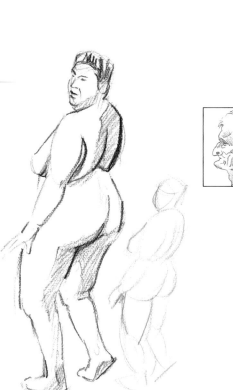

When you draw the face of an elderly person, do not hesitate to make the nose and ears big: these are the only two parts of the body that do not stop growing when we reach adulthood.

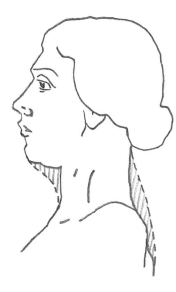

Facial fat can grow to the point of completely obscuring the essential shapes of the human body. The area beneath the chin and the back of the neck tend to show the greatest accumulation of fat.

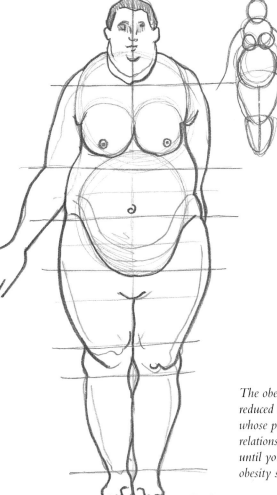

The obese body can also be reduced to circles and ovals, whose proportional relationship can be varied until you reach the degree of obesity shown here.

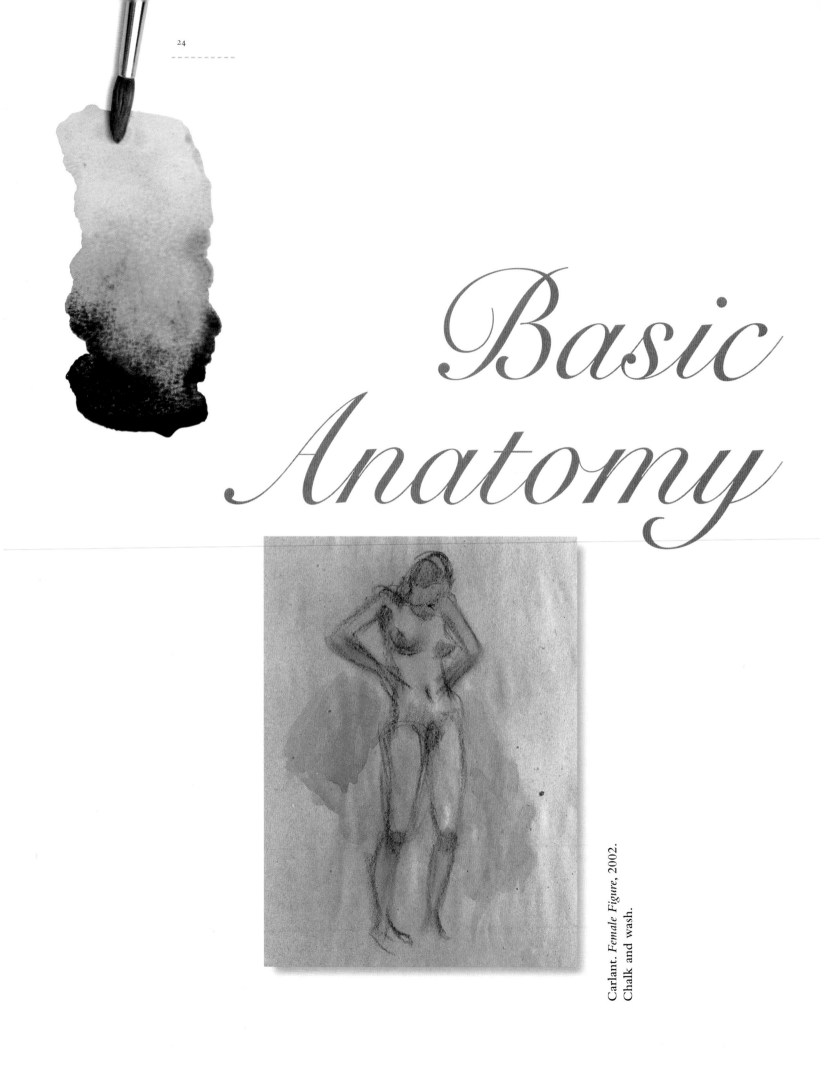

Basic Anatomy

Carlant. *Female Figure*, 2002. Chalk and wash.

AND SYNTHESIS

The shape of the human body depends a great deal on its structure, so an artist's knowledge of anatomy is useful—though not necessary—when he attempts to draw a human figure correctly. If you have no knowledge of anatomy, observation and synthesis is also a good way. Learning to observe your model is fundamental for understanding how the figure is articulated, and synthesis is essential for summarizing or breaking down a subject to its essential parts, into the elements of the figure that have a plastic and pictorial value and into the things that convey the presence and attitude of the figure. The power of synthesis is an enormously useful tool for drawing, because it allows the artist to quickly represent a figure in a spontaneous attitude at any place or time.

The HEAD and FACE

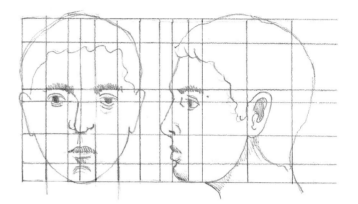

Drawing the head and face is an intimidating prospect, because facial expressions change so quickly that capturing them precisely is a goal that only the most capable artist can attain. Hence, this section will devote no time to studying the action of facial features but will concentrate instead on the relationship of the head, considered as a volume, to the rest of the body.

The Proportions of the Head

According to the law of proportion, the human head equals three and a half times the length of the forehead, so we will divide the height of the head into three and a half units. From this division we derive the following references, which will help you to draw a well-proportioned head: the top of the head, the natural hairline, the position of the eyebrows, the height of the ears, the base of the nose, and the profile of the chin.

Viewed from the front, the human head is like a rectangle three units wide and three and a half units tall. By searching for two lines that divide the rectangle vertically and horizontally, you will find the location of the eyes on the horizontal line, and the central axis of the nose on the vertical line. It is important to notice that the distance between the eyes is close to the width of one eye, and that the lower edge of the lip coincides with a line that divides the two equal halves in the lower unit.

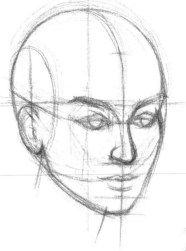

Like that of the figure, the law of proportion for the human head is made up of a set of measurements or units that determine its proportions.

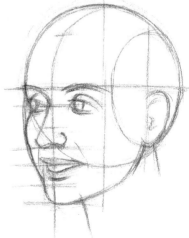

The starting point for drawing a face is the tilt line for the vertical axis. Starting from this line, which divides the face in two, you can begin to distribute the rest of the facial features.

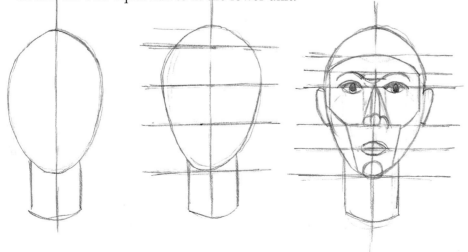

Once you have drawn the oval of the head, draw a straight line going from the forehead to the lower chin. Divide the oval into three and a half parts. The upper line will serve to determine where the hairline begins; the second dividing line marks the location of the eyes; the third designates the nose; and the last shows where the chin should go. The mouth is located in the very center of the last segment.

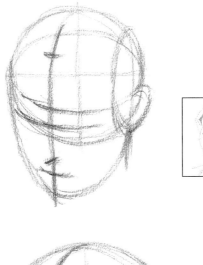

Drawing from the General to the Particular

When drawing the head, one should work from the general to the particular. You must first sketch the basic structure of the head; search for its generic form, its most pronounced or prominent angles. It's enough to draw a set of lines marking the location of each of the elements that will make up the face.

The Face

If you draw freehand, the shape of the face from the front should fit within an oval.

If you trace a vertical line to divide the face in two, you can establish an axis of symmetry that will allow you to place the facial features in a proportionate manner; of course, this is only possible if you draw the face from the front.

The base of the nose is located on a line dividing the face down the middle, and the mouth is somewhat above the chin line. To these lines, you can then add a line for the eyebrows, which will then give you an adequate outline for drawing the head and facial features.

The Head in Profile

The established proportions for the head in frontal view can also be used for drawing the head in profile. All you have to do is extend the horizontal lines and draw each element of the face, only this time, from the side. The same horizontal divisions used for the frontal view also match the placement of the parts of the face in profile.

It's a good tonal exercise to draw a head using flat tones. This practice consists of observing the model attentively and attempting to divide the different tonal areas into imaginary geometric shapes and then coloring them in.

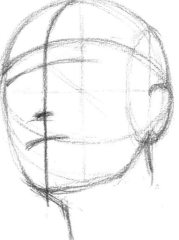

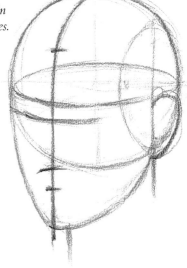

These four drawings of the head in different positions show the changes in the face's measurements when it moves.

Understanding the law of proportion for the head in profile can be very useful when drawing portraits such as this one. It is then a matter of simply adapting the features and proportions of the person you are drawing to the initial measurements of the law of proportion.

The TORSO:
FRONT and BACK VIEWS

If you analyze a frontal view of the torso you will find that this part of the body comprises the pectoral muscles, a set of thick, wide, pentagonal muscles set in pairs, which expand or contract when the arms are raised or lowered. Notice the distribution of volumes, the profile and expansion of the thorax, from the front and the back, and how the shoulders insert themselves into the thorax in different positions depending on the view. The neck gives the torso a great expressive quality, and its musculature implies the flexibility of the head, so it must always be shown breaking from the symmetry marked by the spine.

The sketches below show how to begin a drawing of the male torso. Begin by establishing a vertical axis. From there, use synthetic forms to fit the rectangular form of the torso within this schema; the curve of the torso depends on the position that the figure assumes. For a frontal view, sketch the more prominent muscular textures, such as the pectoral muscles, the abdominal muscles, and the pubic line. In the rear view below, the spine marks the body's axis.

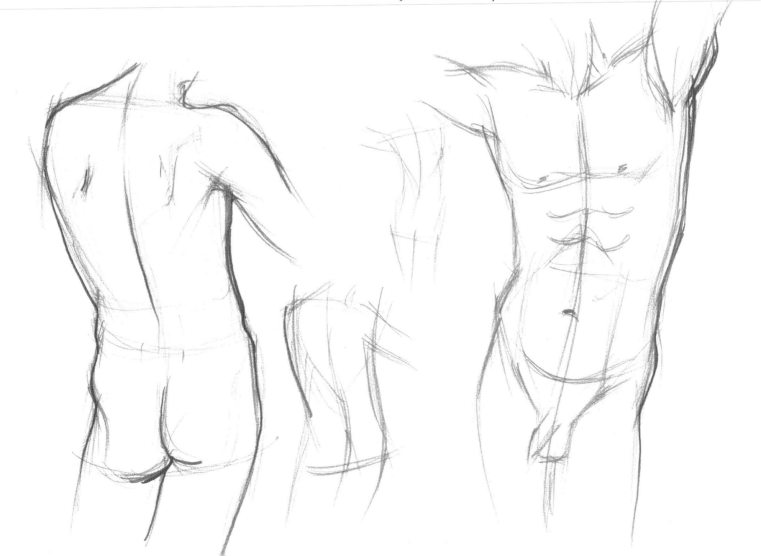

The Body's Axis

If you analyze the rear view of the torso, you will notice that the spine is describes the body's axis: it is a line of symmetry from which the fundamental measurements of the body are established.

Starting from this straight perpendicular, we have constructed a rear view of the torso, taking into account the following factors: the distance between the shoulders and the spine should be equal, even if there is a slight incline; the shoulder blades are the part of the back that stands out most, and its relief is most evident when the model has his arms open. The shoulder blade is triangular and should be accentuated with a light hatching. It's important to notice that the waist is more clearly marked in the frontal view than in the rear view, because from the rear, the surface of the back is a continuous whole from the shoulder blades to the lower part of the lumbar area, where you can appreciate the flesh of the buttocks.

The Female Torso

From both the front and the rear, the relief of the female torso is less conditioned by the muscular structure than the male torso; in it, the transitions between volumes are smoother. Two of the distinguishing features of the female torso are the lower shoulders and more prominent hips. This contour can be easily represented by two triangles joined by their vertices. These triangles should then round out their profile to achieve the curved lines characteristic of the female anatomy.

A good exercise is to find images of figures, seated or standing, nude or dressed, put a sheet of tracing paper over the images, and find the location of the spine and the line of the hips.

The female torso can be synthesized as two inverted triangles. Her profile will be more voluptuous and the line of her hips will be more visible than a man's. When you draw the female torso, keep in mind that its edges should be less pronounced, and more sinewy than a man's.

The UPPER and LOWER LIMBS

Drawing the arms and legs merits a few remarks because it may present problems with proportion. The best way to draw the limbs is to analyze them based on circular or oval shapes. By making a preliminary sketch, we can distinguish between three well-defined areas of any limb. The upper limb comprises the shoulder, which is characterized by the deltoid muscle; the arm, which derives its volume from the presence of the biceps; and the forearm, which is shaped by a more elongated circle. For the leg, we can divide it into the thigh, the knee, and the calves.

The Problem of the Lower Limbs

The muscles in the lower limbs present a more complex form, but after a detailed analysis you will be able to recognize each of them.

The lower limbs are made up of two essential parts: the thigh, where the quadriceps and the sartorius muscle lies, and the leg itself, which consists of the bulk of the tibiae and the calves. The knee lies between these two parts. The knee is the joint that articulates both of these parts, and it should look rounded and prominent when it is drawn. Notice that if you measure the length of the leg from the hamstring to the ankle, the knee is not located in the middle of the leg, but a bit further down, so when you draw the thigh you should make it longer than the calf. The calf muscles are prominent in the lower part of the leg. They begin just behind the knee and end at the Achilles heel.

The upper and lower limbs can be reduced to a sketch of ovals that will prove very useful in drawing the muscular anatomy of these members in their correct proportions.

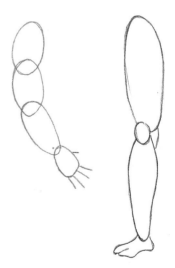

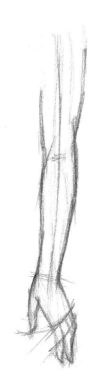

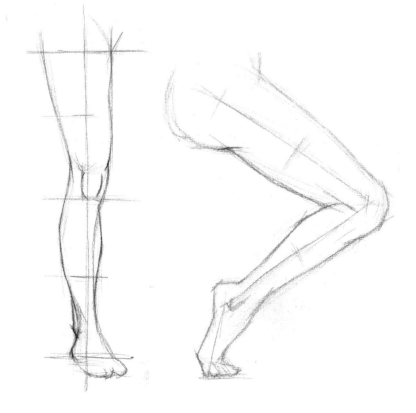

You can use an axis or a straight line that runs throughout the limb in order to situate the joints in their proper measure and to better control the effect of symmetry and the outline of the muscles.

The volumetric treatment of the limbs is easier if you consider the shape of the arms and legs as an assemblage of three cylindrical parts of different sizes.

Women's Limbs

The female arm is very different from that of the male: it is characterized by an absence of prominent musculature, by the regularity of its proportions, and the delicacy of the line that defines its contours. The areas of the elbow and wrist joints are narrower in the female arm. And the shape of the muscles in a woman's legs is barely visible: the thigh tapers delicately as it approaches the knee, and the lines of the leg muscles are understated, softer than a man's, so the circle that forms the knee should stand out only barely. In the lower leg, the graceful calves also taper as they approach the heel. Generally, women's calves are not very prominent, but they do become rounder and gain in volume when a woman wears high heels.

Women's limbs are more delicate, and they display a more subtle muscular relief and a greater narrowing at the wrists and ankles.

In order to draw the legs and arms correctly, it's important that you be able to distinguish the body's cadences and differentiate the positions that the limbs assume, depending on the pose.

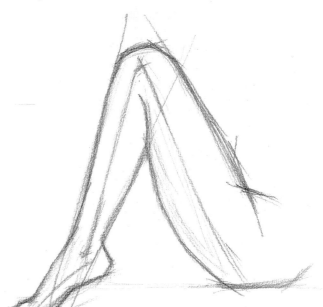

The HANDS:
STRUCTURE *and* OUTLINE

At the very end of the arms are the hands. The human hand has nearly as many important expressive possibilities as the face. The hand is the part of the body that offers the greatest number of different positions. It's important to master its structure and shape, because when drawing the human figure, the hands and feet often end up in very poor shape. The neophyte will often forego the former, or merely suggest their shape, putting them inside a pocket or hiding them behind the model's back.

The Hand's Dimensions

If you take the total dimensions of an open hand, viewed from the back, with the palm and fingers extended, you will find that the distance between the wrist and knuckles is similar to the distance between the knuckles and the tip of the middle finger. This isn't the only fact that you can ascertain by simply opening up the palm of the hand. For instance, you will find that, with the fingers outstretched, the length of the index finger is equal to that of the ring finger, and that the tip of the pinky coincides lines up with the final joint of the index finger.

The hands should be drawn in a proportional relationship to the rest of the body. It can be of great help to follow the general rule that specifies that the length of the hand should be equal to that of the face.

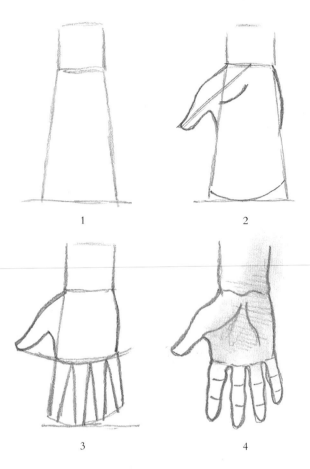

1 2 3 4

We begin with a square and add a trapezoid shape (1). In the upper part of the rhombus we draw a curve to the right, and starting from a straight diagonal line, we draw the thumb (2). From the tip of the thumb we project another curve indicating the point where the fingers intersect with the palm of the hand. We divide this curve into four and project the remaining fingers (3). We then erase the structural lines and draw the hand anew starting from its characteristic outline (4).

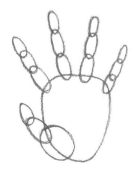

The geometric sketch of the hand is completed with a sketch of the fingers, which are represented by ovals which correspond to each segment or phalanx.

Configuration of the Hand

The hand is connected to the arm by the carpal bones, which form the wrist joint. The hand has two faces to consider: the back, where the tendons and the muscles from the top of the forearm end, and the palm, which has many small, fleshy muscles. The fingers are made up of three small bones each, except for the thumb, which has only two. This forces the amateur artist to take pause and study the particular form of these bones; in doing so, you will discover, for instance, that the bones are thinner in the middle than at the ends.

Synthesis of the Hand

Whenever you draw a hand, try to reduce the metacarpal area to a square unit from which the fingers extend in a radial pattern, or otherwise, start from the oval-based sketch discussed above. You can then continue your sketch of the hand by representing each of the fingers by three ovals, one for each of its segments. If you do so, it will be easier for you to draw a foreshortened hand. The position of the fingers is based on a sketch made up of a series of concentric arches that make it easier to resolve the form in any position. If you can make a well proportioned geometric sketch it will be very easy to adjust the details little by little until you finish the drawing.

Sometimes an unfinished hand makes sense in a nude drawing. Think of the fingers as minor details compared to the other parts of the body.

After studying the hand's structure, it is important to practice drawing the hand in different positions. An interesting exercise is to make a geometric sketch before beginning the definitive drawing, so that you can understand its structure without dwelling on the details. This practice also allows you to observe that the joints in the fingers are laid out in the form of a curve.

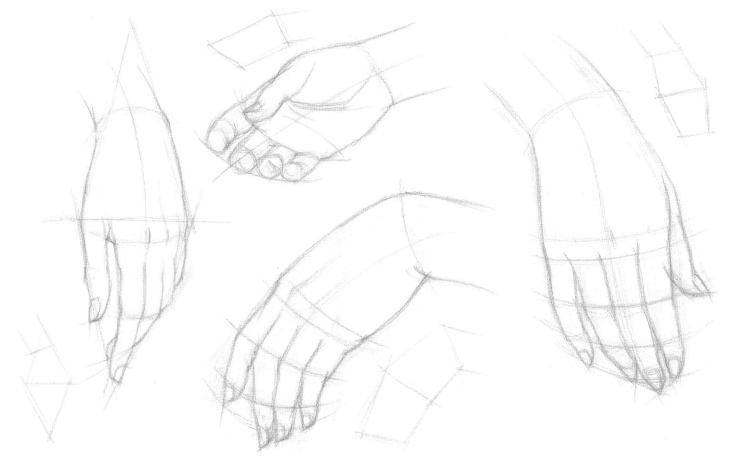

The hip is another main element in drawing the human figure. It tilts on the axis of the spine, and coincides with the point where the legs flex in this area.

The PELVIS:
THE SHAPE *of the* HIPS

The Protrusion of the Hipbone

Because the pelvis is connected to the head by the backbone, it is constitutes the body's axis. Several muscles of the torso, the thighs, and the legs meet at the pelvis, which serves as the main support point for this area of the body. One of the most important parts of the pelvis, and the one which most noticeably affects the outer appearance of the figure, is the iliac crest, which lines up with the hipbone. Don't forget to draw this bone, particularly in female figures and slimmer models. Because a woman's pelvis is wider than a man's, her hipbone is much more visible, marking a soft curvature from the pubic area to the top of the buttocks.

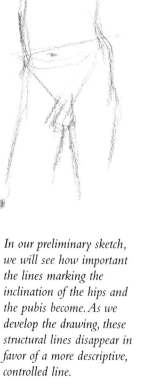

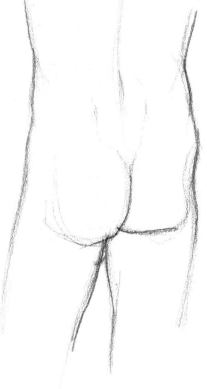

When we make a preliminary sketch for a drawing, it's important to take into account the lines formed by the shoulders and the hips. The tilt of both of these lines marks the equilibrium of the pose.

In our preliminary sketch, we will see how important the lines marking the inclination of the hips and the pubis become. As we develop the drawing, these structural lines disappear in favor of a more descriptive, controlled line.

We shouldn't forget to mark the hip line when drawing a back view, either. Here, the line that marks the underside of the buttocks becomes important as well. Notice the interesting triangular indentation that forms just above the buttocks.

The Line of the Hips

The position of the hips marks an imaginary line in the body that we must take into account when we draw. The line of the hips is seldom horizontal. It tilts on the axis of the backbone, coinciding with the point at which the legs bend in this area, and when the hipbone tilts, the backbone doesn't remain straight, but instead acquires a soft curvature at its base. It almost always adopts a slight tilt, especially when the body is in a resting position, which makes part of the weight of the body come to rest on one leg, while the other leg remains flexed and relaxed. This pose is called contraposto.

If you attend a live model drawing session in an art school, it's important to practice drawing the hips in isolation. Understanding the tilt of the hipbone is essential to correctly drawing the body in any pose.

The pelvis is connected to the skeleton by the vertebral column or backbone, which is always visible through the ridge that runs down the middle of the back. The back of the pelvis is covered by a muscle mass and by the fat of the buttocks, which are much more pillowy and rounded in a woman's body.

The pelvic area is shaped like a truncated pyramid, with a large base and a narrow vertex. A woman's pelvis is shorter and wider than a man's, which allows us to see the smaller bones in the hip through a layer of subcutaneous fat.

The FEET:
INNER STRUCTURE *and* FORM

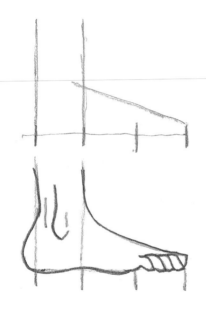

The feet are not as difficult to draw as the hands. This is because the feet have much fewer possibilities of movement. This limitation translates into a more homogeneous and continuous form with fewer problems and inconsistencies.

Configuration of the Foot
As a general reference for drawing the foot, we think of it as consisting of three well-differentiated areas: the tarsal or heel, the metatarsal, and the area of the toes. The silhouette of the foot is conditioned in large part by its skeletal structure. The top of the foot is covered with tendons and tensor muscles, but the joints, although they are every bit as complex as those of the hand, don't display a structure as readily visible as they do in the hands.

Synthesizing the Foot
The geometric sketch of the foot is similar to the one we use for the hand: it begins with a circle or oval that corresponds to the heel, another, more elongated oval for the metatarsal, and various lines or smallish cylinders to represent the toes. Once the sketch is done, you can work on the form, profile, protrusions, and roundnesses of the foot. If you want to give the foot an athletic appearance, draw a prominent heel and svelte toes, with very pronounced joints and phalanxes.

The geometric sketch for the foot is similar to the one used for the hand. It should be defined by a circle that corresponds to the heel area, another oval for the metatarsal bone, and several smallish ovals for the toes.

If you don't want to make a mistake in the foot's proportions, you can divide it into three parts of equal length, in which the first part lines up with the heel, the second corresponds to the middle part of the foot, and the last marks the length of the toes.

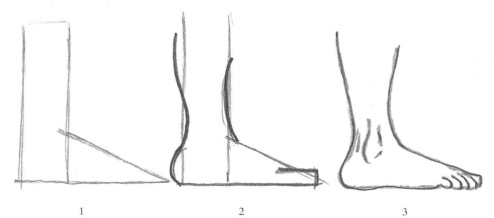

1 2 3

First, we must draw a rectangle for the leg, which, combined with a triangle, will configure the geometric sketch of the form of the foot (1). We then add two curved lines to this sketch, the second of which connects to the rounded line of the heel. A right angle is sufficient for situating the toes (2). We then erase the structural lines and very slowly draw the outline of the foot, this time detailing the protrusion of the ankle and the toes (3).

The Foot in Profile and Back Views

Drawing the foot in profile is very simple. A triangle covers it almost entirely. The shape of the foot is marked by the angle of the heel, the part of the foot which supports most of the body's weight. The toe area takes up slightly less than one quarter of the length of the foot from the heel to the tip of the big toe. A frontal view, on the other hand, presents some problems due to the foreshortening of the toes. But here, too, you can sketch a simple triangular shape, although it will be much narrower compared to that of the profile. The back view is the simplest, and it should have as its main reference point the protrusion of the heel and slight indication of the toes at the other end.

The Bottom of the Foot

The bottom of the foot is also covered with muscles; however, these muscles are not as visible because the skin on this part of the body is very thick, and they all blend into a common mass that spans the arch on the bottom of the foot. This part of the foot has a very rounded appearance due to the greater visibility of the heel and the fleshy, cushioned parts of the bottom of the foot. When drawing the bottom of the foot, remember that the skin here has a rougher texture than on any other part of the body.

Although it does not present a degree of complexity as great as the hands, the foot changes its appearance depending on the point of view or on the type of activity it performs. Our previous geometric sketches will help us to adapt to these new circumstances (A and B). Here, as always, the perpendicular dividing line is of great help in constructing the form and ensuring that, as with the fingers, the toes describe a curve and not a straight line (C, D, and E).

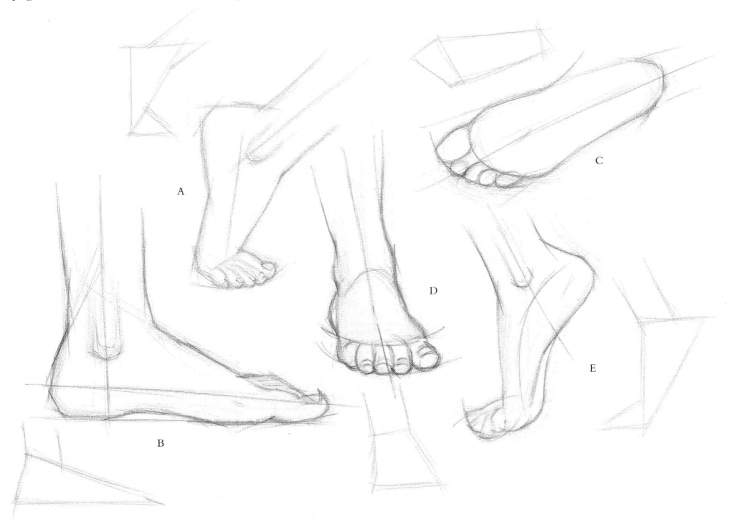

CONSTRUCTING THE *Figure*

"We must measure the body: standing and alive, concretely, in nine parts with respect to its length. For able nature has shaped man in such a way that the face is found in the highest place, so that it be admired and offer the other parts of the body the principle of its measure."

Pomponi Gaurico: *Sculpture*, 1504.

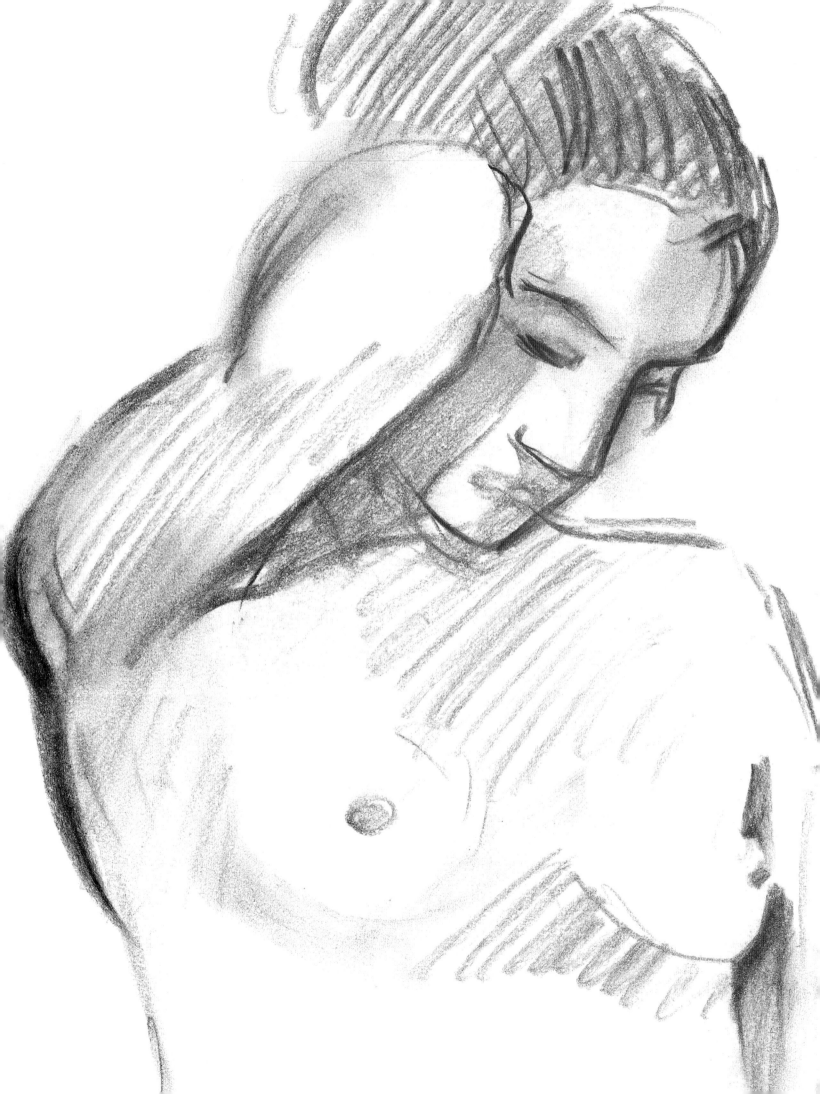

A WELL-PROPORTIONED

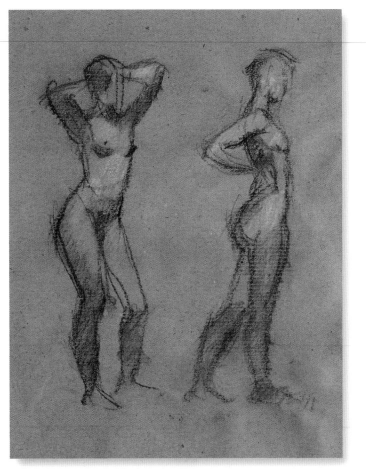

Carlant. *Study with Two Figures,* 2002.
Burnt sienna pastel with outlines in white.

Drawing

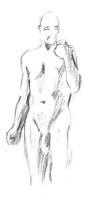

Every drawing must be organized within an rational and comprehensible order, in order to establish a comfortable and appealing path for the eyes to follow. In order to draw a well-proportioned figure, the artist searches for an ideal of beauty, and finds his tools in the objective methods founded upon geometry and measurement. But opposite the purely theoretical systems of proportion, there is what we might call an "intuitive" proportion based on visual comparison and controlled distortion, and we can translate and accommodate the natural structures of the body in a looser, more expressive, and less mechanical way than the model described by the classical laws of proportion.

The UNIT SYSTEM: MEASURING *the* BODY

The law of proportions for the human body would be of little use if this knowledge could not be used with real–life models. Theory is an inestimable help, but it is the application of theory to a real model that determines the final result of any drawing.

Applying the Law of Proportions

Thanks to its measurements, the law of proportions is truly a useful tool for becoming familiar with (and memorizing) the distribution of the relative size of the parts of a figure in relation to the whole. Even if the proportions of a real figure do not match those of a classical model, there is still an adjusted correspondence between the division of the figure into units and the location of different anatomical components such as the height of the shoulders, the chest, the elbows, the hips, etc., which we have to consider. For this type of geometric sketch it's important to first project the body's line of symmetry; on it, we will mark the different measurements of the law of proportion. If the figure is shown from the back, we have the added advantage that the line of symmetry is already marked by the backbone.

In a standing pose, imaginary vertical lines are commonly used to give proportion to the backbone and the lower extremities, in order to place upon them the corresponding segments or measurements for each unit.

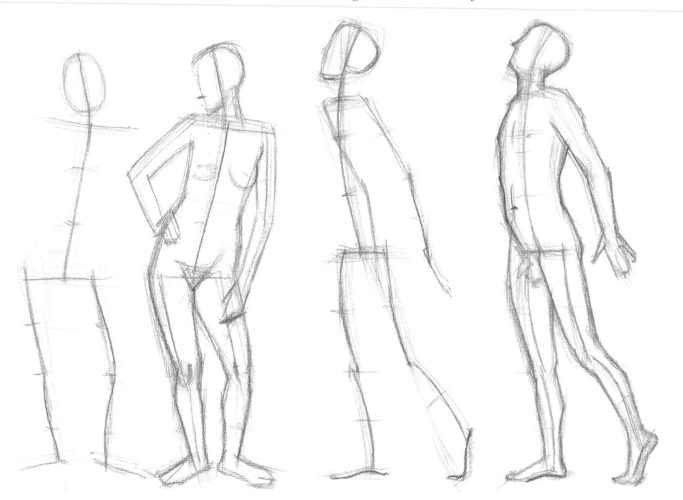

Cross Sections

We are not always able to find standing figures, which lend themselves to the application of the law of proportion, so we must develop a set of rules that allows us to apply the unit system to figures that are seated or lying down. A practical method is to draw cross sections on the body—that is, to draw "horizontal contours" onto the nude body to show the imaginary "slices" that correspond to the different measurements described by the law of proportion. In other words, we follow the same method as we would if we were to build a cylinder-based form.

In a seated figure, these cuts are visible in the folds of the sleeve, the shirt collar, the belt around the waist, etc.

Measurement Problems

Sometimes we will find that the figure does not precisely match the classical male, eight-and-a-half-head model. This is normal. It is only logical that real-life figures should be somewhat beneath classical measurements because, after all, classical laws deal in ideal proportions, not exact ones. What is most important is not whether the figure measures seven or eight heads, but that the distribution of the units be truly proportional.

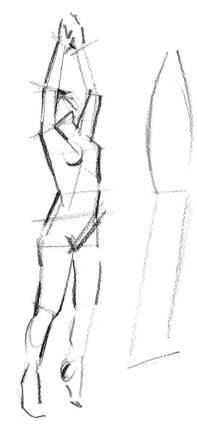

The classical proportions of a standing figure do not change much, no matter how much the body stretches or assumes complicated postures. This system of measurement can be a good reference.

Applying the measurements of the classical law of proportion is complicated when a figure is sitting, lying down, or foreshortened. In these cases, we must draw the figure's supporting inner structure in a seated position and try to adjust the corresponding measurements to it.

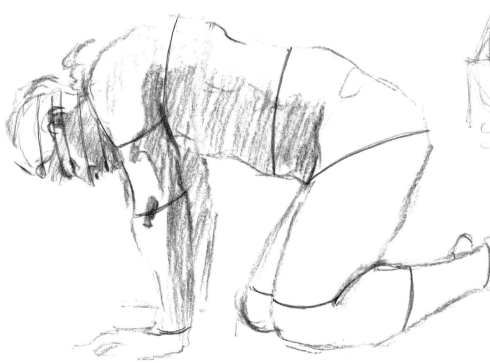

Another system for applying the classical unit measurements is the overlaying of transversal slices, or cross-sections. Onto the sketch of the figure we draw the lines of these sections, which correspond to the segments of the classical model, in order to study the proportional relationships of a figure in a kneeling or lying position.

GEOMETRY *of the* HUMAN BODY

The human figure can be broken down into simple geometric figures that easily adjust to its description. Every pose suggests a general sketch that should encompass the anatomy in just a few strokes. It should be a simple form (an oval, a polyhedron, a pyramid shape, etc.) that is sufficiently rich to suggest the position of different body parts.

The Geometric Sketch:
Structuring the Whole from Simple Forms

To sketch a geometrical model we begin by selecting a composite outline—in other words, a simple geometric shape on which we can inscribe whatever pose the figure assumes. In this way, the work will present from the start a more satisfactory visual layout. The use of compositional outlines in sketching is an efficient method for arranging the subject and adequately breaking up the pictorial space, thus helping to organize the elements of the drawing so that the viewer's attention, and the focal point of the drawing, is where we want it to be.

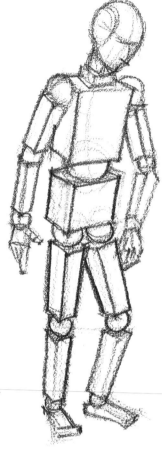

The basis of every correct rendering of the figure is the artist's understanding of its structure.

The human body in its volumetric representation is made up of spherical, cylindrical, and orthogonal surfaces. These shapes are the foundation for drawing the extremities, head, and torso. If the body changes position, all we have to do is adjust the point of view of the rectangles, cubes, or cylinders.

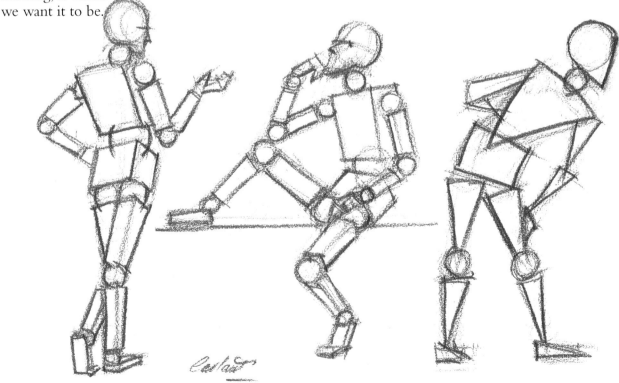

The Essence of Synthesis

Once the compositional outline is complete, we add new geometric shapes to describe each part of the body: an oval for the head, a rectangle for the thorax, cylinders for the arms, a trapezoid for the pelvis. Geometric shapes contain the essence of synthesis. The goal is to combine simple forms which establish the form as well as the proportions of the figure. All of these geometric figures are articulated amongst themselves by observing the straight lines which define the height of the shoulders and the tilt of the hips, and the curve that describes the backbone, which, as we know, is not rigid, but rather produces a tipping of the ischion and the hips, and a rotation or spin that affects the orientation of the head.

Geometric synthesis consists of seeing the drawing as an articulate whole that can be developed simultaneously in all of its parts, and in which no single part is more important than any other.

As an auxiliary system, you can use a wooden model that you can pose however you like. These models are good for practicing geometric sketches.

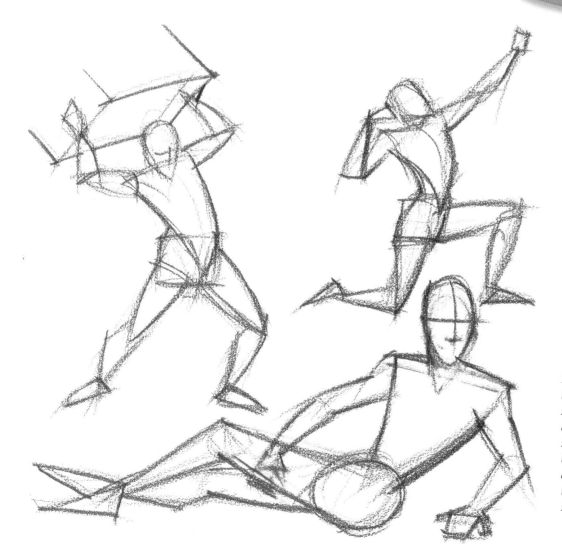

In a geometrical representation of the human body, abstraction should continue until we arrive at a figure made up entirely of simpler forms. Little by little, the bodies will no longer resemble cubes or spheres and will become more flexible, expressive structures.

For the amateur artist, the geometric sketch of a figure is seldom an easy task; nonetheless, it can be simplified by following a few tips. To begin, the best thing to do is try to see the figure as a whole and not get lost in details such as the position of the feet or the shape of the hair. Only after drawing the general outline of the model, when the basic problems of form have been overcome and the proportions are approximately correct, should we address the details. To make a geometric sketch is to understand the drawing as an articulated whole, all parts of which can then be developed simultaneously and of which no part is more important than any other.

The GEOMETRIC SKETCH: STRUCTURING *the* WHOLE *from* SIMPLE FORMS

Before making any geometric sketch, it is important to synthesize the figure, to try to include the ensemble form within a simple geometric form. Geometric forms are used for controlling proportions.

Proportions and Background

A figure's proportions should be harmonized with the dimensions of the background, to make sure that we adjust the figure to the background in a natural manner, and avoid having the margins of the paper cut off a part of the figure because we didn't check the measurements beforehand. If necessary, we can stain the blank page using a paper stump—also called a tortillon—or with our fingertips, to limit the space that the figure will occupy. These initial marks are guidelines that suggest the position and dimensions of each part of the body, as well as the total length of the model. The geometric sketch includes a calculation of the figure's proportions, which should be reflected in the outline.

A tortillon, or even a charcoal-stained cloth, is an excellent tool for practicing geometric sketches. It produces soft lines that are easy to erase or modify.

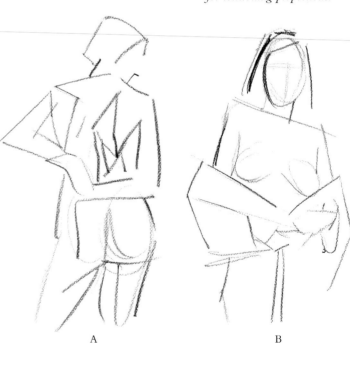

A B

A geometric sketch requires a simple treatment with decisive strokes. We must concentrate on the pose and the proportions and forget all the inner details of the figure (A). The guide-drawing should be a correct preliminary representation of the model which will help us to advance toward a more detailed, definitive outline (B).

The Vertical Lines of the Body

The first thing we must do before sketching is make a series of marks indicating the measurements to which we can refer throughout the entire sketching phase. One surefire way to begin your drawing is to find the line of the shoulders and the head. It is usually easier to draw from the top down. From there we will work downward through the body, drawing synthetic shapes on a standing surface, paying special attention to the vertical lines. We should look for directions and rhythms and see them as abstract forms.

Verifying Dimensions

Drawing freehand allows us to verify the precision of the drawing's proportions during the early sketching phases. When drawing freehand, the pencil should be held vertically with the arm extended before the figure, with the fingertip at one end and the thumb measuring at the other. This will help you confirm the proportional relationships of the real model. From these measurements we can draw by transferring those proportions onto the paper. Once the sketch is done, we once again place the pencil over it to make sure that the proportional relationships between the different parts of the model are correct.

Auxiliary lines can be used when drawing a geometric shape, such as these vertical and horizontal lines, each of which serves as an axis and can be used as a reference point to compare distances.

SYNTHETIC CONTOUR
and LINE CONTROL

Drawing contours is one of the most interesting exercises for an artist to practice, because it centers our attention on the form's limits and provides a focus that we can concentrate on regardless of details, tonal values, or possible modeling effects.

Method

The best way to practice drawing the contour is to take a fine point pencil and start drawing the profile of a figure from a determinate point of view, without taking the pencil off the page. The line should be unbroken and continuous, without erasures, overlapping lines, or tremors. Your eyesight should follow the contour of the figure while the pencil works on the page, responding to each of your thoughts. When starting on the contour or inner silhouette of a new part of the body such as the hands or breasts, you can refer to the drawing in order to find the point at which the new contour should begin. Continue in this way until completing the contour of the figure.

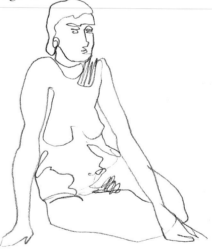

Faulty proportions are typical in this type of drawing, but with practice, the artist will acquire a looser, more controlled line.

The contour should be an automatic, gestural drawing, concerned primarily with the general character of the model and its expression rather than with an academic, perfectionist rendering.

A Great Disappointment

It is very likely that your first attempts at this type of drawing will prove a great disappointment. Don't be discouraged: keep in mind that this method requires a great deal of practice. Once you have gained more experience, you will be able to vary your speed according to your reactions, and your line will be more firm and decisive. The important thing is the experience that you acquire while practicing this exercise. Once you master the ability to synthesize using this technique, you will be able to make studies and sketches in the studio from memory, and won't miss having a model to draw from.

Line Control

To achieve an interesting line in a study, the artist must use either a very fine instrument or a very thick one. In either case, you have to work quickly, and follow the subject's forms with a continuous line. You can use the tilt of the pencil or graphite to modulate the line by altering the width of the stroke. A sharp pencil produces a sensual, fragile drawing, whereas graphite, which has a thicker line, will yield a more intense, energetic drawing. The result should be a satisfactory, uniform line that provides all the information you need for obtaining the model's pose and anatomy.

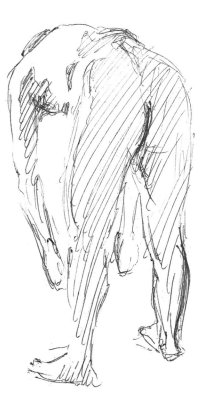

A good exercise for mastering line drawing is to try to render a figure with a single line, without lifting the lead from the paper, as if we were drawing the figure's profile with a single piece of yarn. This helps us develop our improvisational skills and master synthesis.

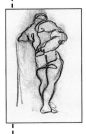

The graphite pencil is one of the most commonly used media for making line drawings, but little by little, the ball-point pen has found a niche among nonprofessional artists thanks to the fine, intense, and tentative lines that it provides.

Synthetic contouring is very useful for making quick studies, when the immediacy and expressiveness of the model are at a premium.

Graphite proves more expressive than a pencil made from the same material because it provides lines of a greater range of widths and intensities.

The VIRTUES of DOING STUDIES:
A GOOD FORM of PRACTICE

The best way to approach a figure and the problems of representation that it entails, is through the practice of making studies of a model. Studying the figure based on a rough sketch is a form of constant learning and perfecting for the artist.

A Minimum of Lines

In a study of a model, you should situate the principal lines with a minimum of strokes, with no concerns over whether the resulting drawing looks unfinished. Doing studies is a valid practice in itself and needn't be justified by a later work. The grace and spontaneity of studies have been appreciated by professionals and amateurs alike throughout the ages.

The Time Factor

Quick studies are notes taken in the shortest time possible. With practice, the hand becomes more assured, so that it learns how to find solutions to any anatomical requirement. The leisurely, inconsequential tone of a quick study makes it especially appealing. Often it becomes a series of small shows of dexterity and visual sharpness. On the other hand, the easiest studies to make are those for which there is no time limit at all.

Your sketchbooks should be full of ideas, suggestive and attractive doodles with no apparent order, nor any goal other than to capture concepts and exercise your strokes.

DESSIN · TE

The Use of Hatching in a Study

In a study, the sketch should be light, never overdone. It is necessary to find a blend of light and shadow that composes the figure with its essential elements. An excessive insistence on hatching is a problem that afflicts inexperienced artists, making their drawings confusing. If you work in graphite, it is sufficient to make a simple, homogeneous gray hatching; if using charcoal, try darkening the shaded areas with a fingertip stained with charcoal.

The hatching of a study should be minimal. It is sufficient to differentiate the shaded areas by using a simple, gray hatching against the white of the page, which represents the lighted parts.

For the beginner it is a good idea to make studies of female figures and, preferably, to choose a model who isn't too thin. A skinny model is harder to draw and demands greater anatomical experience on the part of the artist.

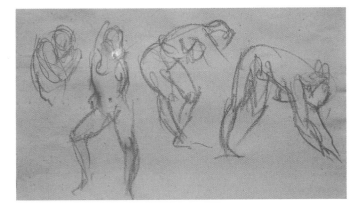

The purpose of a study is not to look like a finished drawing, but to show the evolution of the figure. It should constitute a starting point for more elaborate drawings, or for a study of the definitive pose.

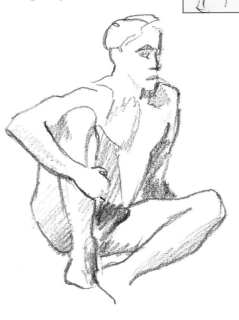

Hatching with watercolor lets you quickly cover a large portion of the model without having to worry about its nuances or details.

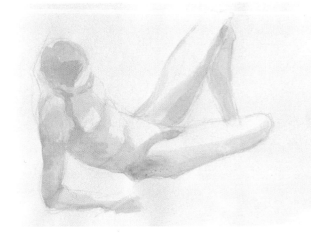

The instruments for making studies should be light and portable. It is a good idea to always carry a sketchbook in your pocket.

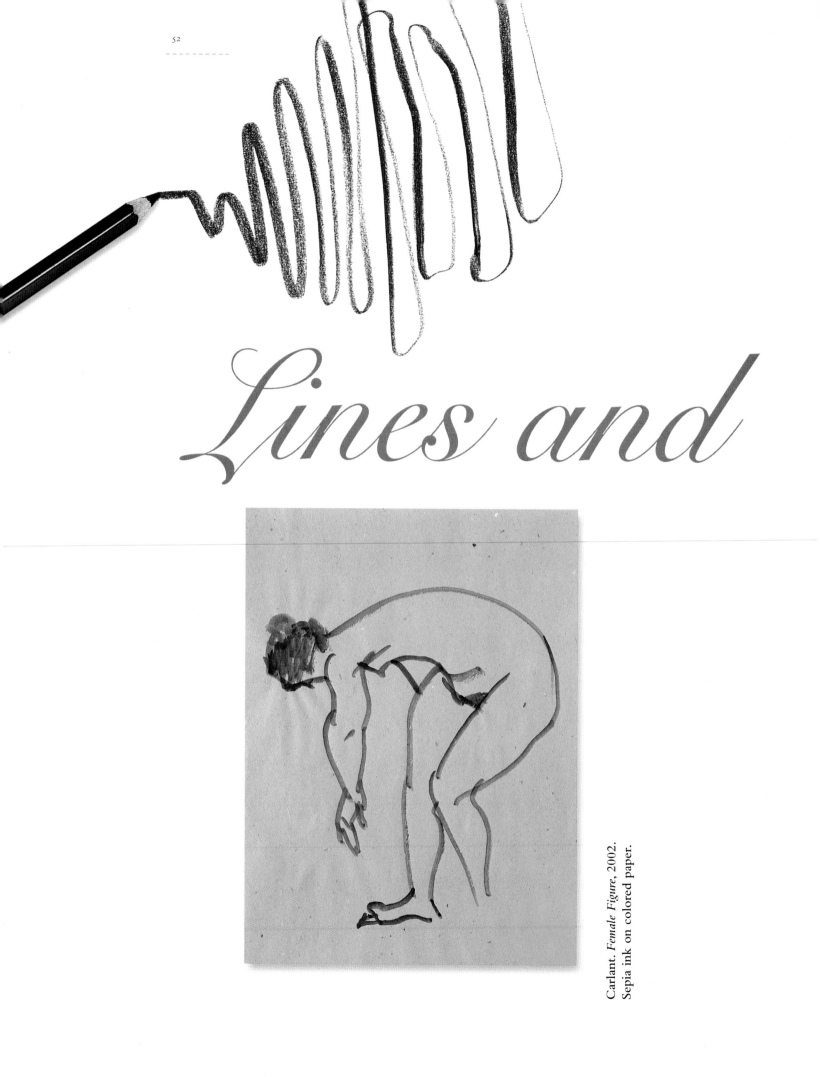

Lines and

Carlant. *Female Figure*, 2002.
Sepia ink on colored paper.

Rhythm
OF THE FIGURE

In figure drawing the mastery of line is very important because, besides defining the concrete contours of volumes and creating a sense of direction or vital impulse in the drawing, it creates tensions and reactions—the particular cadences of the figure. A knowledge of these dynamic tensions gives the figure a sense of contained motion and a rhythmic sensation that can be of great compositional and interpretive interest. Thus, figures appear to be described by a strange equilibrium dominated by action, in a constant entwined motion and violent inflections that are propelled by a force that, although sometimes overwhelming, gives meaning to the pose and unites all of the linear elements of the figure.

Rhythm is an important concept in drawing, taken from the world of music. As in music, it is created by alternating between accents, silences, and neutral passages. A pose has rhythm when it is harmonically dynamic, full dynamic alternations. The distribution of these alternations determines the attraction and interest of the drawing's rhythm. Accents in a drawing are the alterations of its continuity; for example, a diagonal interrupts a vertical line, and vice versa. A static, symmetrically positioned figured is the antithesis of rhythm.

The INNER RHYTHM
of the FIGURE

The Line of Action or Strength

For a figure to attain an impression of equilibrium and rhythm, it is necessary for it to have an internal line, an imaginary line that extends across the length of the figure, in order to articulate its rhythmic effect. This structural line, known as the line of action, should be the basis for any drawing of a pose or movement. Working with lines of force allows us to approach the internal rhythm without the figure becoming unbalanced. When constructing a pose, it is preferable to first exaggerate the line of force and then take it to a more realistic position; thus, we endow the figure with an energy and motion that would probably not be perceptible in a rigid, conventional pose.

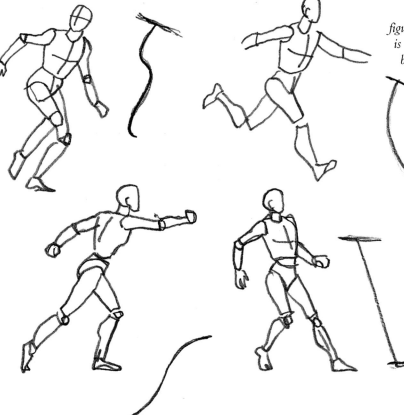

In a back view, the figure's internal rhythm is clearly distinguished by the line describing the backbone.

The rhythm is marked by an internal line that spans the body from the head to the feet and conveys the attitude of the pose or action carried out by the figure. This image shows a series of posable wooden models alongside their corresponding rhythmic lines.

The Expression of Gesture

In order to capture the rhythm of a figure, it is essential to learn to draw its gesture. Your drawing should be fluid, like a doodle, capturing the internal form of the figure and reflecting its intentions.

After drawing the line of strength, attune the gestures of the drawing to each other and capture the essence of the body: don't allow considerations such as the figure's contours or measures to confuse you. The drawing should be quick and interesting, preferably with no consideration given to the contours or forms outside the figure, attuned to its rhythms through the gestures conveyed by your hand.

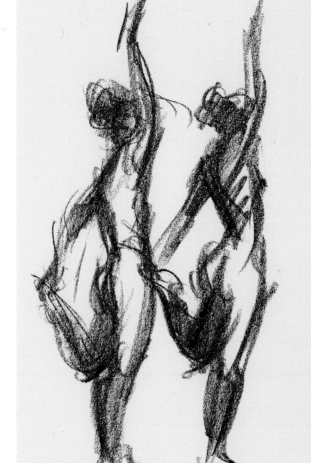

The line of action is the imaginary rhythmic line that spans the length of the figure to produce the effect of motion. In the set of models below, this line is modified according to the action performed by the body.

If we force the rhythmic line of the body, it assumes a more forced torsion, which translates into a more expressionistic rendering.

When making a geometric sketch, it is essential to take into account the rhythm of the figure. The rhythm will be described by curves and quick strokes marking the intention of the body.

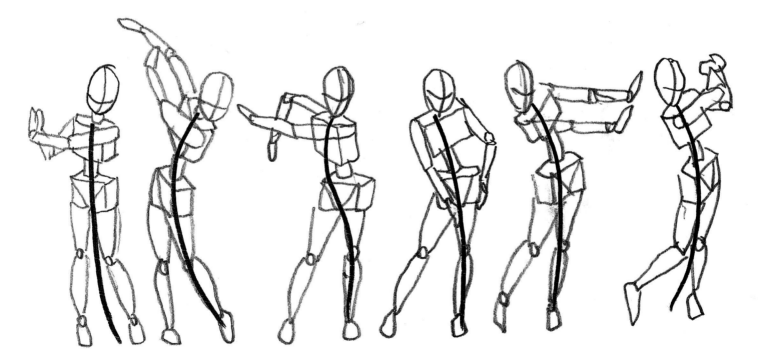

The SOFT LINE
AND ITS MODULATION

The rhythm of a line and its modulation is an important value in figure drawing. An interest in the forms of a nude should be expressed by the charm of the drawing's line strokes. This expression demands some exaggeration, simplification, or even changes, all of which are completely legitimate if they intensify the visual quality of the work. The characteristics of a line used to define a contour can transmit the nature of the form, its materiality, surface texture, and visual charge.

Descriptive Contours

Descriptive lines are those whose only goal and function is to describe the profile of forms and their volumes. These lines are responsible for the stylization of the forms that we have previously discovered, and they reflect the artist's personal vision and stylistic essence. Descriptive contour develops an authentic creation and organization of anatomical form.

When drawing modulated lines, not just any stroke will do. The five lines below left represent the most common strokes used by novice artists—they are broken and hesitant. The four on the right are the kinds of lines amateur artists should strive for: firm, but varied in their intensity and thickness.

Descriptive contour is expressed by a continuous line stroke and has a purely compositional finality. It functions as a geometric sketch describing the profile of the figure without regard for its volume and modeling.

Modulated strokes affect the depth of the lines. Their thickness varies depending on whether the area being drawn is in light or shadow.

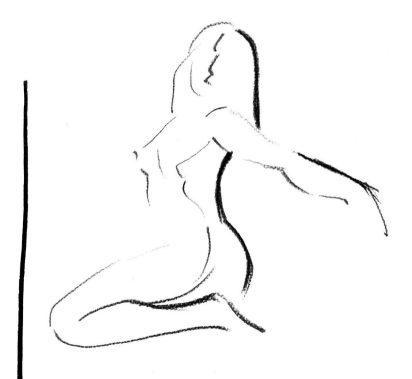

Once you have enough practice with different kinds of strokes, you will be able to modulate the line easily as you draw. Modulating the trace means varying the pressure and thickness of the line according to the needs of the drawing, in order to describe the volume of the figure and its most significant tonal changes.

A fine trace is always associated with the presence of light on the figure; it comes as no surprise, then, that a fine line was used to render the left-hand profile of the figure below. A thick line represents a greater presence of shadow and, thus, marks a much more definitive trace, drawn with a generous stroke.

Contour Intensity

If a line is the same consistency throughout, it encloses the nude too coarsely, and fails to express the nuances of light and shadow. A drawing rendered in soft lines should alternate thick lines with finer ones. Fine lines suggest a lighted area, while thick lines are perceived as describing shaded parts. You can emphasize a line by retracing it to give an illusion of depth or create shadows. If the thickness of the line is modulated and the tracing is agile, the line will have sufficient visual appeal that it will only require a few summary additions in its hatching.

Line and Synthesis

Drawing in soft lines is in large part a synthetic exercise in selecting contours. Linear synthesis plays an important practical role when drawing the human figure because it allows us to quickly render a figure in a spontaneous attitude at any time or place. A synthetic figure or scene contains all the necessary information for the viewer to recognize the figure's different actions and gestures, capturing the grace of its motion.

For a better understanding of the preceding cases, consider this sketch of the same figure, in which lighted and shaded areas are clearly differentiated by a tenuous gray hatching.

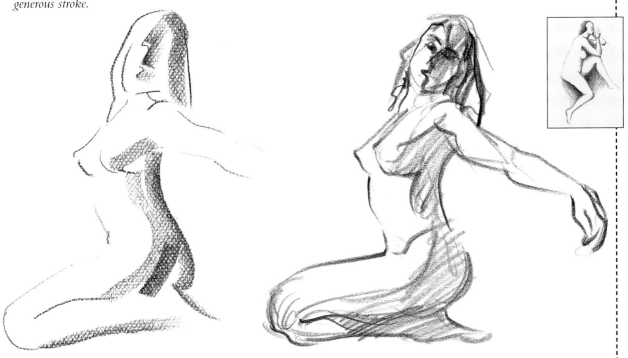

An effective way of mastering the soft line is to draw the silhouette of a figure without taking into a count its solidity or any other internal projection. Follow the outer edge, ignoring what goes on inside. The objective of the contour drawing is to achieve an exact correspondence between the what the eye sees as it follows the edges of a form and the line the hand draws to represent it.

Volume depends as much on hatching as it does on line. But the correct gradation of shadow is what allows us to represent anatomical relief effectively. A well-graded model with no overemphasis is what gives the figure its correct, organized form as an organic whole.

TURNING SPOTS
into FORMS

Shading

If a figure is lighted powerfully, it can be sketched with spots of color, with hardly any lines at all. The drawing should be a synthesis of light and shadow, of lighted areas which we leave blank on the page and the shadows that we stain using charcoal or a piece of chalk laid flat. This process omits the details altogether, but includes the spectrum of middle grays. The limits of the shadows are also as good a reference as the lines of a box-sketch, particularly in models that have a well-defined outline whose contour presents a clear contrast with the background.

A few spots are sufficient for suggesting the human anatomy. If we want to shade quickly we can use the classic gray hatching, which consists of stretches of parallel marks. Notice how the lighted areas are left blank, with barely any lines or marks.

When the figure has sharp contrasts in light, it can be sketched with spots instead of lines. In each of these three cases the spots work to shape the appearance and pose of the figure.

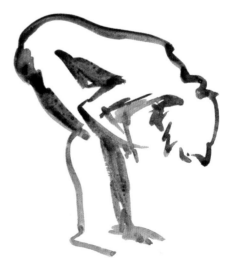

Hatching

In a rough sketch, hatching can be made with a motion that mimics your first, tentative lines, achieving a preliminary tonal and modeling intention. The strokes can be decisive or shaky. This technique relates the construction of shadows to the expressiveness of the stroke, so it is linked with calligraphic matters closer to the realm of writing. This allows for much greater gestural expression in a sketch based on hatching.

Drawing with Watercolors

A good way of setting up the drawing is by practicing tonal watercolors. Before starting the drawing itself, we place the model in front of a single source of light, because shadows become confusing if there are several sources of light at one time. Before hatching, we can lightly draw the outline of the figure in order to have a template or guideline for working. Then, using a flexible brush, we quickly and nimbly apply dark watercolor on the areas of the body that are shaded, preserving the white of the paper for the more brightly lighted areas. You will have to forsake any intermediate tones: precision is unimportant in this drawing, so don't waste time repairing forms and outlines.

3. Finally, we can add a few strokes detailing the structure and profile of the figure. The line strokes combined with the spots give the drawing greater consistency and solidity. These strokes were made with a pencil the same color as the spots.

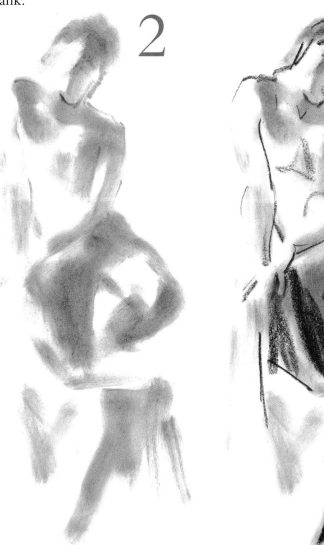

1. In these three sequences we shall see how to practice sketching with spots. First, using a tortillon or a cotton ball lightly stained with chalk, we draw the shaded parts of the model on the paper in a highly synthetic, simplified manner, leaving the lighted areas blank.

2. The tones that serve as the basis for the sketch are now complete. The series of spots traces the structure and principle masses of the figure and provides information about the location of the light source.

ATTITUDES OF THE HUMAN FIGURE:

The Pose

"As painters, we seek to use the motions of the body to show the motions of the soul (…) Thus, it is crucial that painters have a perfect knowledge of the motions of the body and learn from nature in order to imitate, however difficult it may be, the multiple motions of the soul."

León Battista Alberti: *The Three Books of Painting*, 1435.

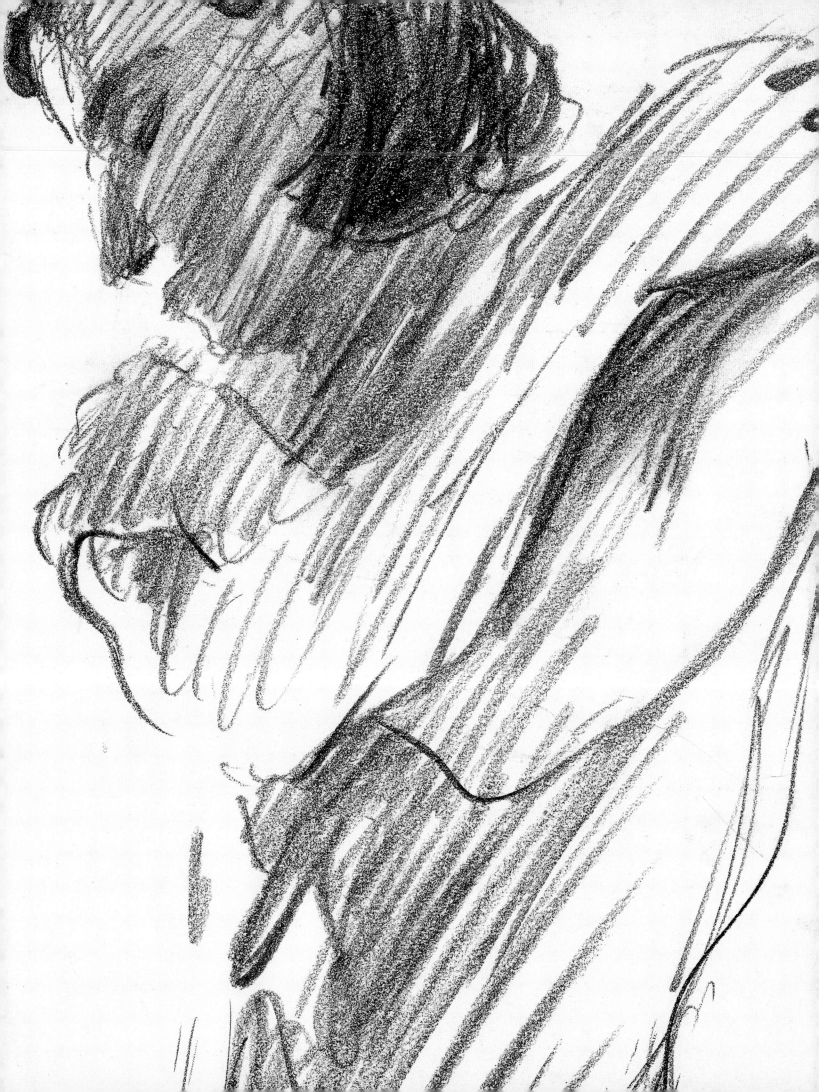

ANALYZING POSES

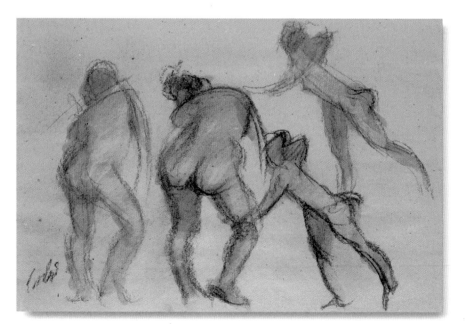

Carlant. *Figure in Various Poses*, 2002. Chalk and watercolor.

and Gestures

There are no limits to the possibilities for creating interesting, striking poses. Capturing the energy and dynamics inherent in the model depends in great measure upon the artist's choice of pose and gesture. When we speak of gesture we refer not only to the model's mannerisms or the features of the face, but to the entire body. Every person has a particular way of walking, sitting, posing, and manifesting herself physically; these are the unequivocal marks of her person, and we call these marks gestures. The gesture of a figure transmits its way of being alive, its action. By defining the expressive angles and directions of the body, we can capture the essential gesture of a pose, implying its intention and energy in a natural way.

The EQUILIBRIUM

of the POSE

The equilibrium of the nude is a very important factor—the verisimilitude and stability of the composition depend on it. Every new pose presents a different problem to be solved in its compositional balance.

The Stability of the Figure

The equilibrium of the pose is an important factor when drawing a figure. There are limits to how much a human being can tilt to one side or another without falling over. The task, then, is to control the stability of the figure so that it does not appear to be falling to one of its sides. The question of equilibrium is not a problem if the figure is seated or lying down. The risk of imbalance occurs when the nude is standing, particularly in poses that involve any violent movement in the figure. In this type of pose, it is possible to become disoriented and lose the horizontal axis, creating an appearance of instability.

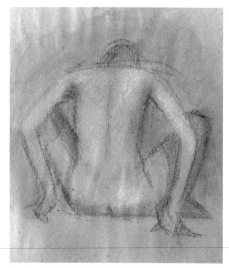

In a back view of a nude, the line created by the backbone can be used as an axis of symmetry, allowing us to balance the pose.

A symmetrical composition presents greater stability and balance. In artistic drawing, symmetry should not be perfect. The most common solution is to displace the direction of the head or one of the arms to avoid an effect of total symmetry.

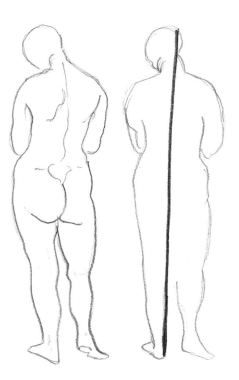

The line of gravity spans the length of the figure from top to bottom, from the neck to the base of the supporting leg, on which the weight of the body rests.

Firmness of the Feet

The figure, no matter what pose it assumes, comes into contact with a supporting surface through one or both feet, the buttocks, or the hands. The manner in which this contact is produced explains the support as well as the coherence of the pose through equilibrium, so the entire body should appear coherent with respect to the position of the extremities. A frequent error when drawing standing figures is that they do not appear to be touching the ground, and look as though they are floating or imbalanced.

The Center of Gravity

A rational method of verifying the equilibrium of a nude's pose is to find its center of gravity. The center of gravity is usually found in the abdominal area for standing figures, or at the base of the spine for a nude viewed from the back. To check the stability of the figure, all one has to do is imagine that center of gravity and extend an imaginary vertical line from it: if the line divides the area supporting one or both of the feet, the figure has a good equilibrium; otherwise, the representation is imbalanced and the nude is unable to support itself on its feet.

Symmetry

In a flat representation and in a frontal view, the human body shows a series of visible correspondences and symmetries that give the figure a great sense of compensated equilibrium. For this analysis, the most important line is the one that divides the human figure in two when viewed from the front.

A frequent mistake that amateur artists make is to tilt the figure forward. To avoid making this mistake, you have to project the line of gravity onto the sketch.

To achieve a well-balanced figure, it's important that the position of the legs be convincing and that the feet be firmly supported on the floor. If we take these factors into account in the sketch, the rest of the figure should appear balanced.

The line of gravity allows us to control the equilibrium of the figure. In the first case, the line of gravity, drawn in red, falls outside of the foot supporting the pose, so that the figure appears imbalanced (A). On the other hand, if the figure falls in front of the line of gravity, as shown in the drawing below, it will not appear imbalanced (B). The equilibrium of the nude can be verified by drawing the vertical line of gravity and checking whether it falls within the area of the foot supporting the figure (C).

A

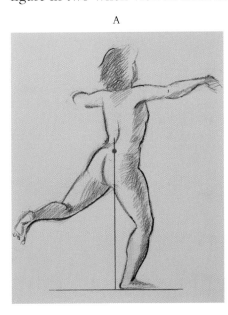

B

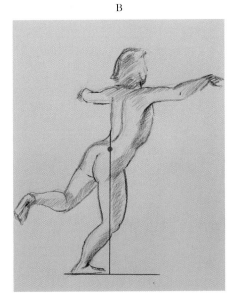

C

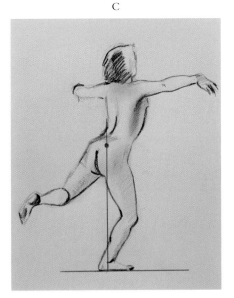

VARYING *the* POINT *of* VIEW

Whether the sketch is static or in motion, it is interesting to draw the figure from different points of view and walk around the figure it as you sketch. Every point of view offers the option of a different pose. Drawing the figure from the front, from the back, or in profile implies a different technical and psychological technique.

Studying the Pose

Before drawing a nude, the artist must consider which aspects he wants to develop in his work: line, hatching, color, chiaroscuro, movement, etc. Certain poses allow one to develop some of these aspects better than others, as we have already said. It is interesting to observe the model from different points of view and walk around the figure as you sketch. The best exercise for determining the focus is to look at the scene as a whole—to walk around the model, choosing the most expressive and effective angle. Every point of view constitutes a different possibility. Technically, every pose requires different solutions, with a greater or lesser role assigned to drawing, color, or chiaroscuro.

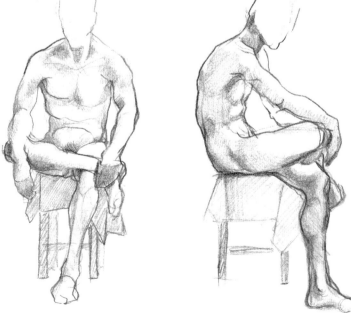

The frontal view is among the most attractive to draw: not only does it provide a view of the face, but a frontal view of the body presents reliefs and details that make the hatching and modeling of the figure more interesting.

In order to better understand the model, you have to study it as a whole, and analyze the same pose from several different points of view, walking around the model and visualizing it in its entirety.

The Frontal View of a Figure

To draw the nude from the front implies personalizing it, transforming it into a particular person rather than a generic model. Thus, this type of pose more closely resembles the idea of a portrait. Although the purpose may not be to make a portrait, the frontal view of a nude forces the artist to pay serious consideration to the face, and this means endowing it with expression.

The Nude in Profile

We could almost say the opposite about the nude in profile. The contour is the dominant aspect of a drawing of a pose in profile: the form of the head, facial features, shoulders, torso, abdomen, thighs—in short, of the entire figure. These elements can be represented with a single, continuous line. This does not mean that the volume and modeling are unimportant, but rather, that they are subordinate to the line of the figure. It is worth remembering, however, that a figure is rarely entirely in profile. Some parts of the whole appear only in a frontal or back view, making a three-quarters view advisable.

The Nude Figure Viewed from Behind

The back view of a nude, especially the female nude, is a recurring subject in the genre of intimate figure drawing. These drawings create the effect of a figure being observed by the viewer without her knowledge.

This impression of naturalness proves to be of great psychological interest. Technically speaking, a rendering of the back—male or female—can accentuate the anatomy to a degree that it becomes interesting in its own right.

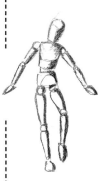

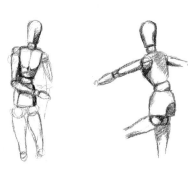

The figure in frontal view requires a more personalized treatment of the face and a sketchier rendition of the rest of the body; the model in profile, on the other hand, requires a more detailed treatment of the body's contours.

If we find it hard to understand the figure from different positions, we can use a model like this wooden mannequin. As an exercise, it is very practical to place the dummy in the same pose as a live model, turning it and making sketches of it from different points of view.

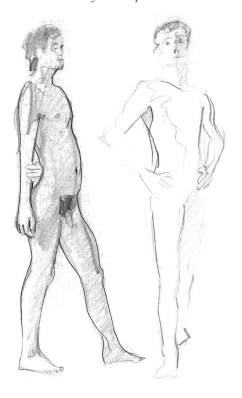

A back view of a figure requires little personalization but a great deal of modeling to help describe the volumes of the body.

A COUNTERMOLD:
DRAWING NEGATIVE SPACE

Often, the success of a pose lies in its negative space, in noticing and rendering the form of the background, the empty spaces surrounding the figure.

If we draw the forms of these various spaces, we also end up drawing the figure, but with greater ease. We solve the problem of composition thus: the spaces and the forms are united when we give equal importance to all the pieces of the puzzle within the margins that limit the format.

Analyzing the Countermold

The important thing isn't drawing an arm or the position of the legs, but rather taking up the form of these body parts by relating them abstractly to the space that surrounds them, looking for the negative forms, or countermold, of the figure. Therefore, in order to understand the forms of the model we must know how to identify the figure's countermold.

We suggest a very simple exercise that consists of representing the human figure in the chosen pose by drawing the different chiaroscuro values of the shapes that surround the model, without using lines to give them their counters—simply using hatching based on tracings that reduce the contours of the body. We realize it isn't easy to separate the figure from space, but with a bit of concentration and practice it can be done.

A good way to analyze the pose is to forget about the internal forms of the model and concentrate on its profile, drawing from the hatching of the empty spaces that envelop the figure.

The application of a countermold in the hatching stage is a common effect for artists, the objective of which is to underscore contours and profiles by using tonal contrast.

Solving Foreshortening Problems

We propose the following method as the most effective means for solving some particularly difficult problems, such as foreshortened figures. The only realistic solution to the problem of foreshortening is to draw the figure just as it is, not as one imagines it to be; to see it as a geometric figure, observing the negative space surrounding it. Only dexterity and experience can help one to really see and correctly render a foreshortened limb.

The application of a countermold is especially useful when the figure presents complex poses such as those we observe in a contraposto. In these cases, we will try to visualize the empty spaces in the figure's exterior in order to correctly sculpt the pose.

Above all else, keep in mind the spaces contained inside the figure. If they do not match the same form as those in the real model, the figure has not been sketched correctly.

A sketch should not be a representation of an isolated figure but an interaction of the figure with the surrounding space. Dark lines in the background space also help to define the profile of the head and shoulders.

WAYS *of* SEEING *the* FIGURE:
OPEN *and* CLOSED APPROACHES

How an artist "sees" the body will determine which approach he or she will take in expressing the figure. Among other factors, the artist will have to decide if the drawing will have an objective, descriptive theme, or a more subjective and open interpretation.

The Closed or Descriptive Drawing

The finished or descriptive drawing presents the visible reality of the figure in a way that shows off the mastery and ability of the artist. The radicalization of the analytical function magnifies the finished effect of the drawing. The profile of a descriptive figure tends to be linear and closed, leaving no space for improvisation and subjectivity; it is limited to the re-creation of visual experience. Descriptive drawings display a constant effort to forsake convention and give greater importance to meticulous analysis, so that the drawings translate into an exact rendering of the human figure.

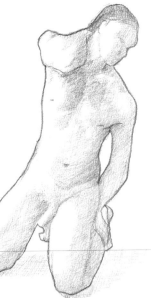

The closed figure is typified by a linear treatment of the figure's outline and a rich interior modeling. It is the closest to a classical or academic treatment.

A geometric sketch made with closed figures provides solid figures with thick lines that accentuate their outlines and volumetric modeling.

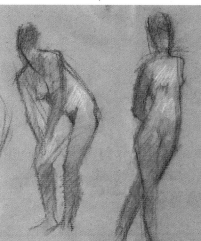

The contour of the figure is usually depicted fully in a closed drawing. All of the figure's anatomy, as well as the light that falls on the body, are clearly defined, leaving little to the imagination of the viewer.

Ink produces a uniform, lasting, worn-away line that proves very attractive when making suggestive, rough sketches of open figures.

The open figure is a bid for poetry, ingenuity, and creativity instead of academicism, for suggestion, rather than rational order.

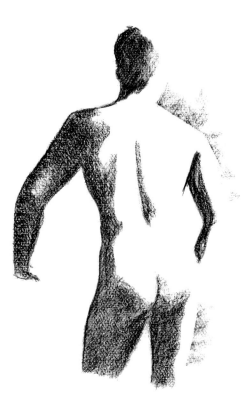

The Open Drawing

In suggesting the form instead of explaining it completely, the open drawing requires a more poetic treatment, allowing the spectator to complete it in her own imagination. The open drawing, through its brevity and immediacy, can also be a medium for crystallizing ideas. It is accomplished by suggesting certain areas rather than completing them, subtracting a fragment of the drawing for the purpose of interesting the viewer or drawing her attention toward that point and allowing her imagination to deduce or complete it. Suggesting the form means responding quickly and spontaneously to the artist's vision of the model and tracing the precise moment of that vision onto the paper. Naturally, this means that the artist's compositional problem is more or less solved, and the geometric sketch of the model is already more or less correct.

Open figures are characterized by a near absence of lines in the lighted parts of the body, so that the spectator must establish where the figure ends and the background begins.

A geometric sketch of an open figure is always suggestive and somewhat indefinite, and should look unfinished, not quite solid.

The standing figure generally presents fewer problems, because each part of the body can be clearly visualized. In cases where there is a problem with the body's proportions, we can always turn to the classical law of proportion.

The STANDING POSE
or CONTRAPOSTO

Symmetrical or Asymmetrical Figures

Representations of the human body are rarely symmetrical. Artists always try to draw the model when it is out of balance, making a motion with its arms, or in a determinate position. The frontal, symmetrical view is used only in handbooks for studying the body's proportions and practicing drawing in general, and is rarely represented outside this context.

A frontal representation of the standing figure should avoid excessive symmetry; symmetrical poses are better suited to anatomy textbooks than artistic drawing.

During the early stages of learning, it is a good exercise to copy classical sculptures in plaster, which eliminates the problem of color in the drawing. The plaster model is ideal for practicing form and the representation of light and shadow.

Any sense of movement presented by the standing figure's body is determined by the contraposto. To represent more forced poses it suffices to accentuate the slope of the lines of the shoulders and hips.

The Contraposto

Contraposto is one of the most commonly drawn poses. The contraposto or ischiatic position is determined by and inclination of the torso in the opposite direction from the pelvis. It is so named because the ishion, a bone located in the upper pelvis, tilts to one side or the other depending on the position of the figure. Thus, the weight of the body rests on one leg while the other leg appears relaxed, in an attitude similar to a soldier at ease. This tilting motion of the hips is usually accompanied by the tilting of the thorax in opposition to the pelvis. You can put this to the test at home if you like. Stand in front of a large mirror. Keep your feet apart so that all of your weight is evenly distributed, and then rest all of your weight on your left leg. You will find that your hipbone tilts upward at the same time as the shoulder line tilts down, and vice versa.

If we analyze the body's skeleton, we find that if the weight of the body rests on one leg more than the other, the hipbone line tilts to one side (1). When drawing the torso, its line tilts in the opposite direction, creating the contraposto position (2). The upper torso is clearly defined by the line of the shoulders, while the lower part is defined by the line of the hipbone; with this in mind, notice how with the tilt of the hips, the knees appear to be at different heights (3).

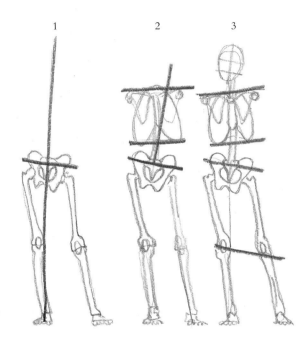

The contraposto is one of the most common poses for standing figures; it is the pose that breaks the effect of symmetry and gives a certain rhythm and movement to the body.

This brief sequence show the process that every artist should follow when drawing a figure in contraposto. First, it is necessary to situate the lines of the shoulders and hipbone (1). After making the geometric sketch, we proceed to the other parts of the body, keeping in mind that the knee of the leg that supports the body's weight is higher than the other (2). Lastly, we erase the structural lines and render the muscular relief synthetically (3).

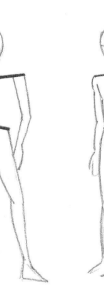

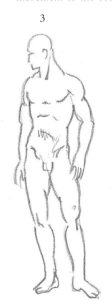

SEATED *and* RECLINING FIGURES

Seated or resting figures enjoy special favor among amateur artists, among other reasons because they present few compositional difficulties, and the body seldom presents excessive tensions because the muscular anatomy is relaxed. The greatest problem that we might encounter when drawing this kind of pose is foreshortening, but we will discuss this later on.

The Seated Figure
The seated figure involves several different complications beyond those of the standing figure; in it, the joints and members are not shown as extensions of the body, but as different surfaces that must be connected to each other through line and shadow. It is necessary to pay attention to the dorm of the joints and the existence of hidden areas, because these will reveal to use where each limb begins.

In the male figure, the muscles lose their rigid appearance because this implies hardly any muscular tension; here, the hatching softens the intensity of the anatomical relief. In the female figure, the breasts appear smoother, less tense. Drawing the chair on which the model is seated is not absolutely necessary, but if you decide to do so, do not diminish the centrality of the figure itself and render the chair only sketchily, leaving out the details.

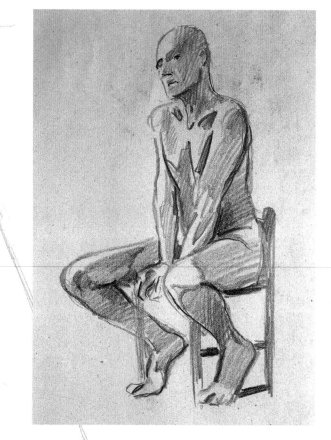

Seated poses are the easiest to draw because the model's muscles appear the most relaxed; nonetheless, they require a greater number of successive surfaces, and force the artist to draw while imagining areas hidden by the body.

A quick way of sketching a seated figure is to establish a line or central axis that divides the body in two and serves to balance the pose. The different lines surrounding the body serve to verify the alignment and correspondence between different points on the body.

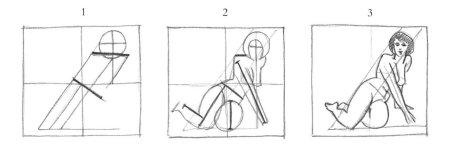

1 2 3

As we know, seated figures present difficulties when applying the laws of proportion, so different methods must be used in order to sketch it precisely into position. One such method is to begin with a preliminary drawing depicting the tilt of the body and the lines of the hipbone and shoulders (1). Then, the length of the extremities is measured and they are sketched into place (2). The study is completed by drawing a few structural lines and verifying the contours of the figure (3).

The Reclining Figure

The reclining or resting figure conveys a sense of calm, which allows for a more relaxed focus than when the model is in an uncomfortable position. In this type of pose it is harder to find visual alterations such as contortions or foreshortening, because everything lies relatively inside a parallel plane. In this case, the objects related to the figure drawn can be of great help. If the figure is lying on a sofa, the rectangular plane of the sofa helps us to find the right degree of inclination in the resting body.

In almost every drawing of seated or resting figures, we find angles or planes that recede into space, sometimes very abruptly, so the point of view implied by the figure is very important.

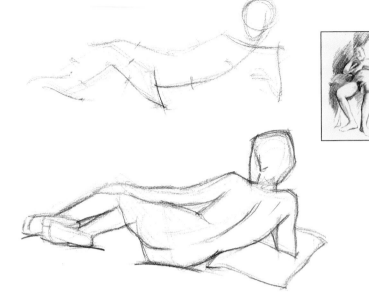

If the reclining figure is seen from the back, the backbone proves an interesting constructive axis. We can mark the proportional location of different parts of the body in relation to this line.

Objects related to a seated or reclining figure can be of great help. If the figure is reclining on a bed, the rectangular plane of the bed can help achieve the correct degree of recession for the figure lying on it. A few strokes are enough to insinuate the supporting surface.

The reclining figure viewed from the back is the most impersonal pose for a model, as well as the pose that requires the greatest control of line and modeling.

POSE *and* MOTION:
The EXPRESSIVE LINE

Drawing the figure in motion means drawing a living figure. Every movement expresses something. The mission of every artist is to learn how to represent this action or that expression. To represent movement is to understand the group of bends and extensions that take place within a motion—the bends and extensions corresponding to every pose.

Drawing the Muscles

The muscles are the driving force of the body, putting the figure in action, in motion. Knowing how they move is a great help, because drawing figures in motion means putting visual memory into practice, even when the period of time is very brief. The interesting part of drawing things in motion is discovering, and learning how to depict, the essence of that movement: the tense muscles of an athlete, the equilibrium of a ballerina, the speed of a runner. The different muscular tensions are underscored by the intensity of the hatching. The greater the contraction of the muscles, the greater the energy that must be represented by the contrast between light and shadow.

Studies of movements should be imprecise, precipitous, with little attention paid to the details, and a generous gesture in which the line describes the figure's inner rhythm.

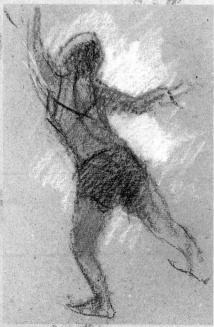

When drawing a figure in motion, we must put aside proportions for the sake of freshness, spontaneity, and rhythm, even if doing so means deforming some parts of the model.

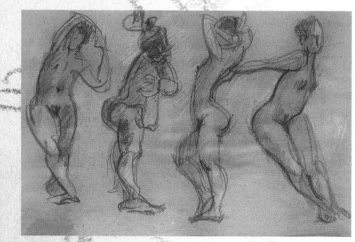

The effect of a sequence in motion justifies making a study of a figure in the course of performing an action. In this case, the passage of time and the action are represented as a succession of poses that demonstrate the different steps taken by the figure while performing a dance.

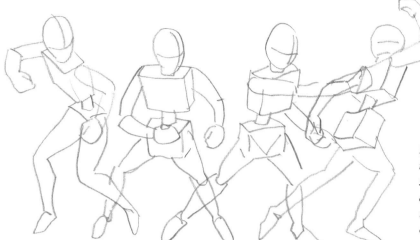

If we draw a figure in motion, it is important to make several sketches such as these, which analyze each of the positions the body assumes in the course of performing the action.

Quick, energetic lines give the sensation of movement to a figure. Notice how a quickly drawn sketch, rather than a detailed, meticulous drawing, is better at expressing movement in a figure.

Deformation

When drawing a figure in motion, the artist should get carried away by the vision of the moment and forget academic considerations. The artist can go so far as to alter the body's proportions as a function of movement: increase the width of an arm or leg, exaggerate the curvature of the back, or suppress unnecessary details. Sometimes the trajectory of a single line explains much more than an accumulation of traces. If the line is lively, it conveys the figure itself, giving it a more vital gesture.

In drawings describing motion, the lines of strength should be very expressive; they can even be exaggerated to give the figure a degree of deformity.

Successive Images

This technique represents movement through successive images, with each figure in a different position placed on the same plane in order to represent movement sequentially.

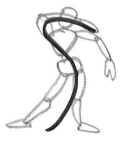
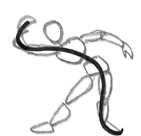

Vanishing

Vanishing, or fading the contours of the figure, is a common technique for suggesting action. The source of this effect is the blurry or unfocused images seen in photography. The dispersion of the figure's contour imbues it with an effect of vibration, movement, and displacement.

The blurred or unfocused image is a very common technique for suggesting motion. This technique is the counterpart in drawing for the concept of the blurry image in photography.

DRAWING *the* HIDDEN PARTS *of the* BODY

Sometimes, when drawing a figure, it is necessary to draw lines where there are none, or, to be more precise, where we do not see them. In some seated or reclining poses some parts of the body disappear from view and remain hidden behind the body. Thus, in order to understand the structure of the figure, we must construct an imaginary contour that crosses the body in order to relate the visible limb to the one that remains hidden from view.

Advanced artists perform this process mentally, but the beginner can make use of a drawing depicting the line and structure of the figure to understand how the hidden parts of the body are articulated. To this end, it is often useful to draw the model as if it were transparent, drawing the views of the body that remain hidden to the spectator.

Drawing the figure as if it were transparent should be done using a soft, clean line that can be erased easily. Once the structural drawing is finished, the lines of the hidden body parts can be erased.

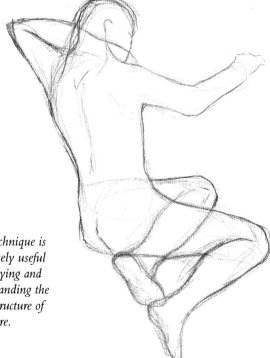

This technique is immensely useful for studying and understanding the inner structure of the figure.

The most difficult part of this drawing method is finding the flex points and the places at which the joints connect to the body in order to produce a coherent drawing.

Studying the Joints

If a figure is not in an upright position, it presents several problems of some complexity, in particular with regard to the composition of the legs, and especially, in those places that hide other parts of the body (an unseen knee, a foreshortened arm, a leg hidden behind the body).

When drawing, it is important to pay attention to the shape of the joints and the existence of hidden parts of the body, because they reveal where each part of the body begins. A good way of rendering the structure of a figure when some of its parts are hidden from view is to draw the figure as if it were transparent. Doing so makes it easier to place the hidden parts within the context of the drawing; we can then draw the details of the drawing within the limits defined by these lines. This method of drawing requires a great deal of observation in order to determine where each of the lines in the drawing originates, to locate the joints or flex points, and to note where they come to rest within the structure of the body.

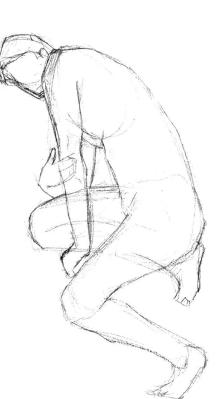

When you practice drawing transparent bodies, you should start by reducing the figure to simple, geometric shapes—prisms, spheres, and parallelepipeds.

The technique of transparent drawing is more than an exercise for studying the structure of the model. Some artists also use it as an interpretive technique or as part of a personal rendering style.

FORESHORTENING:
DRAWING *the* NUDE *in* PERSPECTIVE

One of the greatest problems in drawing seated or reclining figures is foreshortening—representing the human figure or one of its parts in perspective. The art of foreshortening consists of representing the human body from points of view at which its dimensions are diminished by perspective. But foreshortening is not the same as ordinary perspective—there is no need for vanishing points or any of the methods employed in linear perspective.

Altered Proportions

To approach a drawing of a foreshortened figure, we must make a greater effort to adapt the different proportions of the figure on the page, because the different parts of the body are altered considerably by perspective—an arm or a leg that seems to advance toward us, a hand or a foot in which the fingers or toes are perpendicular to our line of sight. Knowing this, the artist has a new factor to consider when choosing the pose best suited to her intentions.

If we have problems drawing a foreshortened reclining figure, the best thing to do is enclose the figure in a box drawn in perspective. The box acts as a guide for reducing the size of the limbs through the effect of perspective (A).

Once the preliminary sketch is done, we can erase the structural lines and shade in the figure (B).

The projection of the box in perspective tells us how we must adjust the proportions to the disposition of the figure. In this way, the part of the drawing closest to the foreground always ends up falsely enlarged in relation to the more distant parts of the body (C).

A common technique for drawing the foreshortened figure is to give greater definition to the foreground and leave the middle- or background sketchier and uncolored. Compare the treatment of the feet in this drawing to the others (D).

Keeping Proportions in Mind

To render a foreshortened figure, it is necessary to know the figure's proportions, as we have seen. Having the proportions at hand makes it easier to interpret the diminished proportions produced by foreshortening without making mistakes or distorting the figure. But it is as important to pay attention to what we see when we study a pose—and loyally render all of its peculiarities—for the result to appear realistic.

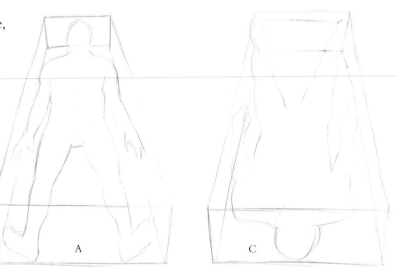

A

C

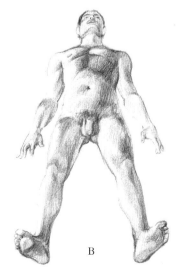

B

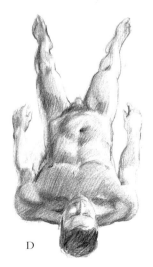

D

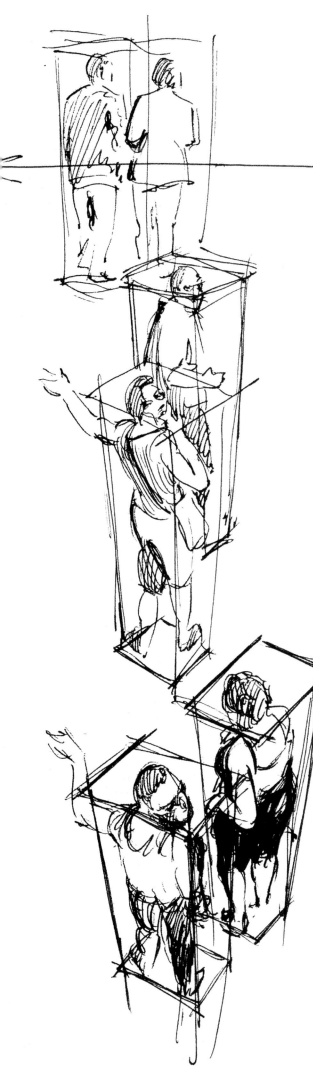

The Foreshortening Box

Perhaps the theory of foreshortening is most easily understood if the figure is enclosed in a box divided into equal units along the back. When the box is stretched out with the feet in the foreground, the units grow smaller as they recede from the viewer. Therefore, the general rule is to make the viewer see the parts of the figure closest to him as larger, or oversized—almost exaggeratedly so. The most common completely foreshortened pose is the lying figure observed from above. From this position, the closest dimensions appear much larger than the more distant ones; it is necessary to always respect the figure's appearance without trying to correct its apparent deformations that make this kind of pose interesting and give it meaning.

The Dynamics of Foreshortening

Foreshortening is an exceptional medium for representing movement, the energy and drama derived from the human body. This is how the great masters saw it when they included in their paintings figures seen from the most varied points of view and in the most dynamic poses.

Let's take a look at a practical example of foreshortening. The figures at right are standing on an escalator. The figures at the top of the escalator are less foreshortened than those closest to the bottom, which gives us an almost aerial view of them. This setback can be overcome by enclosing the figures in boxes and locating the line of the horizon at the top of the escalator.

In reclining figures it is common for some parts of the body to be foreshortened. In this case, the foreshortened arm looks oversized and appears to be reaching toward the foreground of the drawing.

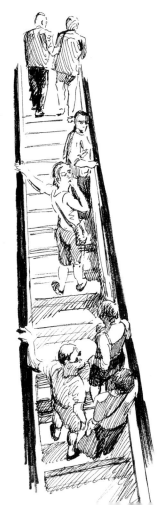

Light
and
Shadow

IN THE HUMAN FIGURE

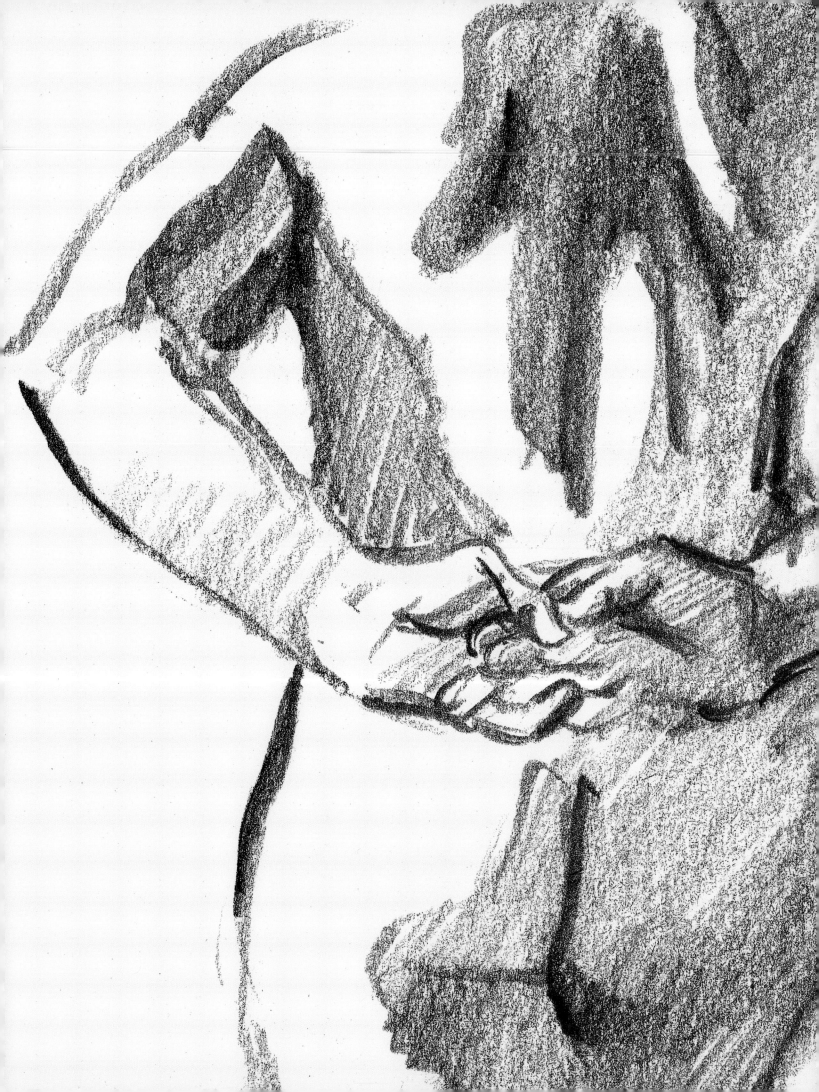

TONAL

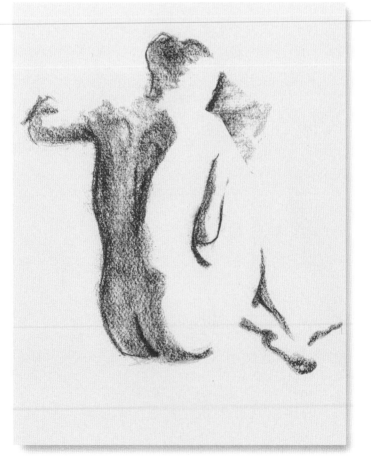

Marta Bru. *Female Figure*, 2002. Pastel.

Techniques

As you gain confidence in your ability to represent the human figure in an exact manner, you will inevitably want to give your work a greater sense of three-dimensionality. This can be achieved by means of light and tone, and, concretely, with the representation of hatching, which can provide volume, drama, atmosphere, solidity, and greater depth to the corporality of the object. The appearance of shadow in the figure breaks the boundaries of the drawing, establishes near-pictorial categories, and reinforces the objective, tangible concept of the representation.

The light source is a fundamental part that must be considered carefully when rendering the shadows on the body. These shadows define the form of the surface on which they appear, or give nuance to form admirably, indicate the time of day, create dramatic effects or express a determined emotional atmosphere in the drawing. The direction of the light in the drawing should be studied well in order for all the shadows to appear on the side opposite of the main light source. In a lateral position, the light leaves the opposite side of the model in shadow, and the volume and relief created by the shadows projected.

The EFFECT of LIGHT on the NUDE

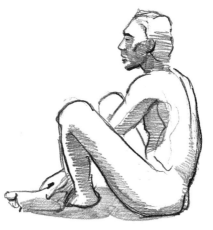

The Effect of Light

Form only becomes visible as a function of light. Light creates volume and other effects; it is an essential part of any artistic representation of the nude. With enough light it is possible to identify every relief of the figure's body. That is why we must study the path of the light. First, locate both the darkest areas in the figure and those that are most exposed to light. Then, establish an order for the different intermediate values visible in the figure. This comparison is always based upon the idea of contrast: "one shade darker than another," or "one shade lighter than another."

Shadows are always projected onto the side opposite the source of light. If we vary the intensity and direction of the light, we will find that the figure's appearance also changes, exhibiting softer features, for instance, or more dramatic effects, depending on the case.

It is sometimes interesting for beginning artists to make simplified sketches such as this one in order to learn how to place the shadows as solid blocks, as if they were homogeneous "stains." This exercise is very useful in understanding the relationship between the direction of the light and the projection of shadows on the figure.

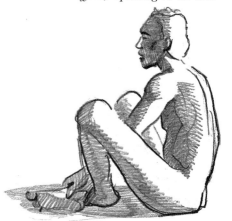

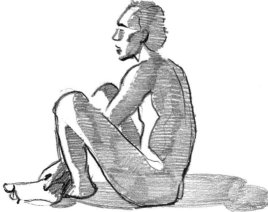

We can make drawings out of shadows alone, omitting all the traces or lines that mark the figure's contours. Here, using a clearly synthetic effect, we have located and limited the shaded areas to achieve a minimal expression of the figure.

Direct and Reflected Light

Direct light sheds light on the body, so in those areas where it falls we must use the lightest values—often, the blank surface of the paper, with no hatching at all). Shadows come later, through a progressive gradation of darker shades or a decisive contrast with the lighter areas. Apart from these fundamental lighter shades, reflections almost always appear in the shaded areas of the figure—areas lightly illuminated by the reflections of light on the surfaces surrounding the figure. Reflections are never as dark as deep shadows: their tone is in between that of the darkest shadows and the most well-lighted areas of the figure.

Shadows on the nude create a true drawing, a series of non-anatomical contours that give the figure a sense of drama.

Reflections

Bright reflections and projected shadows are as important as the effect of direct light on the figure. These effects are a constant in reality: every object is affected by reflections and shadows that alter its color. The same is true of the figure. To render it with a single source of light is an artificial technique. The colors surrounding a nude project their shadows and reflections onto it; light creates surprising harmonies and effects, and reflects on the surface of objects, giving clarity to the figure from many different points, and creating shadows that alter the continuity of the lighted forms.

Hatching is the next phase in the outlining and profile of a figure. Hatching techniques are complex and varied, and therefore deserve special attention from the artist.

By putting different degrees of pressure on the chalk, we can obtain different light intensities in hatching.

SKETCHING
a TONAL DRAWING

When drawing with the flat length of a stick of chalk or charcoal, the important thing is to sustain a continuous line, varying the position of the stick in relation to the page.

A "map" of shadows is a good method for studying the distribution and intensity of shadows on a figure. The purpose is to assign each value referenced in the squares at left to the corresponding parts of the body, according to the degree of lighting.

Charcoal makes the task of hatching much easier: the thick, flat trace of the charcoal stick makes it possible to render shaded surfaces very simply, reducing the terms of light.

The Map of Shadows

The easiest procedure for modeling or "sculpting" a figure is to organize a set of tonal swaths of light and shadow. This means breaking down the image into defined areas, using light, intermediate tones, and shadows—both those on the figure and those it projects. The result of this analysis is a "map" that can serve as a starting point for later corrections or improvements. Making this sketch requires you to reduce the many different tones present in the live model to just a few tones. As a general rule, it isn't necessary to have many gradations in contrast in order to create the illusion of depth in a drawing.

Working with the Flat of the Chalk

One of the most attractive ways of beginning a figure drawing is the flat stain produced by dry media such as charcoal or pastels. With charcoal between your fingers, it is possible to outline the main forms of a figure in a highly synthesized way, alternating use of the thickness of its flat surface with the line of its point to render the form only to the point of intelligibility. The stain of the flat side of the charcoal helps render the darknesses of the body. The fewer lines or stains are used, the fewer there will be to correct. Once the figure has been sketched, the rest of the drawing need not be rendered with this degree of intensity. Some areas should be rendered as a hard, charcoal incision on the page, allowing you to reinforce the main lines of the figure.

Rendering Broad Tonal Groups

To begin hatching a figure we must avoid the assignment of values according to a sequential regimen, which implies making the drawing section by section and creates the risk of quartering the figure and obscuring the reading of the body's volume. The best method is to establish broad tonal groups before manipulating their smaller, constitutive tones. To do so, we establish each tonal increment by adding a layer of hatching and repeating this operation until we arrive at the desired darkness.

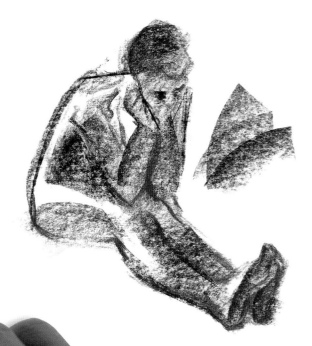

The best way to render a preliminary stain is to apply continuous hatching with charcoal combined with intense linear stroke.

A B

If we apply the charcoal with the same pressure throughout, we achieve very broad, textured swaths of shade (A). If we put more pressure on one of its edges, we obtain a broad, graded stroke of decreasing intensity (B).

Example of how to hold a piece of charcoal to draw with its side.

The PROCESS *of* HATCHING: CREATING VOLUME

A drawing made only with lines does not sufficiently define the volume of the object represented. Hatching is the most common tool for modeling forms, and also one of the skills that takes the longest to practice during the learning stages. It is necessary to shade along the entire figure without stopping to work on the details, looking for spots of shadow that can give the figure its total volume in such a way that, once the contours have been put into place, it will hardly be necessary to consult the model in order to add the essential shadows.

Dragging the Width of the Bar

The most common way of hatching with charcoal, chalk, or pastels is to drag the width of the bar across the page, using it to create a thick, broad stroke that reveals the texture of the paper. Depending on the force with which the bar is dragged, it is possible to vary the intensity of the trace, and even fill out an area entirely until the grain of the paper is closed.

The first hatching should be done quickly with the flat of the stick. When drawing on paper with a visible grain, the hatching will exhibit an interesting speckled texture.

Notice the difference between crosshatching, which produces a dynamic, contrasting effect (A); and using stains that allow for smoothing or blending and a sculpted effect on the body (B).

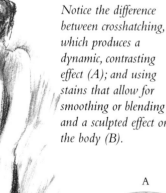

A

B

Hatching Versus Tonal Drawings

We can hatch using a motion that mimics the curvature of the object, and thus, achieve a strong, modeled texture. The hatching effect allows for better gestural expression than drawing with sculpted tones. When using cross-hatching, or hatching across the original shading in a reiterative way, we cover the entire surface of the paper and give greater intensity to the hatching. We must be coherent with the direction of the traces in order to unite the different tonal areas and give coherence to the drawing. The tonal or stain-based drawing, created mainly with smoothed and blended spots of charcoal, chalk, or pastels, serves as preparation for a painting or for a drawing of greater breadth. When considering the application of charcoal, pastel, or chalk stains on the paper, begin by applying light pressure on the piece and gradually increase the pressure as the drawing progresses. This method of hatching achieves an atmospheric treatment with a grainy texture and no lines or abrupt tonal changes, with no trace of the individual stroke.

Studying Values

In a traditional drawing, the study of values is mainly approached once the preliminary sketch is finished and the the contours of the figure have been established with a structural line. Evaluation is a way of creating volumes by making gradations within a single tone. When speaking of evaluation, we must think only about black and white and forget about colors. Starting from this monochromatic gradation, it can be said that values are tones, or, to be more precise, the different intensities of tones. These values enable the representation of light and shadow by increasing or diminishing their intensity.

Once the first phases of staining are completed, the drawing requires greater precision in evaluation. We can then use the edge or point of the chalk to make more definitive markings in each area.

The direction of the hatching depends on the external relief of the figure. For instance, if we draw a spherical form, the hatching should be circular (A); in a cylindrical surface, the hatching should also describe a curve (B); if the surface is flat, the hatching should describe a straight line (C).

To create a figure with a rich gradation of values, we must forget about lines and conceptualize the model in black and white. The graphite pencil's great variety of harnesses and formats makes it a preferred instrument for hatching, with a wide spectrum of possible tones.

EFFECTS *of* VOLUME

Often, when we draw the human figure, the final result appears flat and unrealistic. This is a serious problem for many artists: the human figure should have a rounded, three-dimensional form.

Modeling

The technique of modeling is used very frequently by artists who aspire to a sculptural corporality in the nude, to an almost tactile sensation that the forms are curved and occupy deep space in the representation.

Tonal gradation leads to modeling the nude—in other words, to creating the effect of volume. Modeling is a direct consequence of the gradation of light and shadow on the body of the figure. If we want our portraits to appear more three-dimensional or more solid, we can "model" them with charcoal or pencil and then fuse the hatching with a tortillon, or even with our fingers.

When we render the volume of the wrinkles in a figure's clothing, besides grading the intensity of the grays, it is essential to control the direction of the shadings. The raising of volumes with a graphite pencil is delicate and creates few abrupt tonal shifts.

The greater the contrast in the modeling, the greater the effect of the figure's three-dimensionality will be.

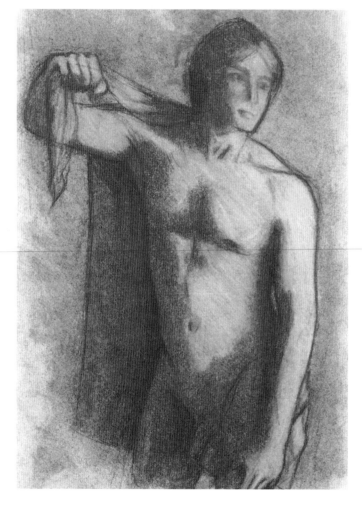

For better modeling, it is preferable to work with charcoal sticks rather than a charcoal pencil. Charcoal sticks smooth and blend easily, while the pressed charcoal of a pencil produces very intense lines that are hard to blend.

Forcing Contrasts

A richness of reflections and shadows can be produced by the artist by surrounding the figure with elements that create nuances on the skin. The reflection of light on a white cloth makes shadows lighter; if the cloth is red, the shadows are tinted with this color and shade the body with its tone. Similarly, if an object interrupts the trajectory of the light, its shadow will be cast on the nude, creating an effect with potential pictorial interest.

Transitions Between Shadows

Transitions between shadows—from light to dark and dark to light—are produced through different means depending on the media employed. In pencil, these gradations are achieved by tightening the trace and accumulating crosshatches to darken the shadow; with charcoal, the darkening is made by intensifying the impression of the stick, and the transitions are produced by fading the stain of the charcoal; the process with chalk or pastels is very similar. The fading can also be done with a tortillon.

Controlling the Direction of the Stroke

To produce the effect of volume on a figure, we must control the direction of the stroke. It is not sufficient to apply hatching; we must impress upon it the proper direction. For instance, the hatching of an arm should be circular. In a curved surface such as the abdomen or buttocks, it should also describe a curve. On the other hand, if the surface is flatter, such as a back or a torso, the hatching should be straight. As a result, the form of these strokes should be consistent with the waves and reliefs of the body.

Modeling is based on the correct description of the reliefs of the human figure, and it begins with smooth transitions or gradations between tones.

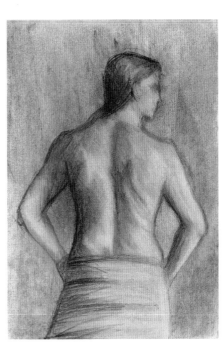

Modeling means sculpting with soft transitions of light and shadow, producing a tactile appearance in the figure so that its textures and the folds of the skin are revealed by the light as it falls on them.

The effect of smoothing is essential in developing a correct modeling. When the presence of the line is suppressed, the tonal effects gain prominence, producing a more pictorial effect in the figure.

Chiaroscuro is the gradation of shades of gray from white—usually given as the blank paper—to the most intense black that we obtain by drawing.

CHIAROSCURO EFFECTS:
WORKING *with* ABSOLUTE CONTRAST

A Dramatic Effect

Chiaroscuro is the most dramatic of lighting effects. It consists of subjecting the nude to an intense light source that divides the anatomy into very brightly lit areas and and a total darkness that blends into the background. This effect was used frequently by the painters of the Baroque period to intensify the drama and expressiveness of their works. The more intense the chiaroscuro—hat is, the greater the contrast between light and dark values—the greater the resulting sense of volume, and the more evident the effect of light on the figure will be. Similarly, a greater contrast between light and shadow produces a greater number of intermediate values that must be included for the forms to maintain a continuous surface. This also holds for the volumes of the nude, which are rounded and in which the transition from lightest to most shaded is produced in a smooth, progressive manner; when this transition is interrupted abruptly, the shadow appears sharper and the effect is a contour.

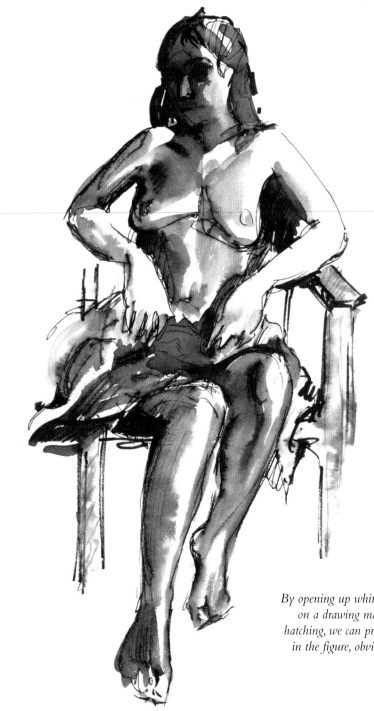

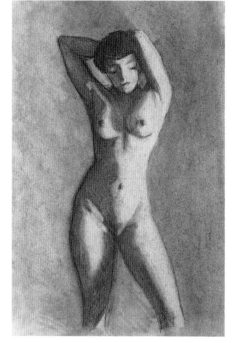

To work with chiaroscuro more easily, focus a single, intense light source on the figure's side.

By opening up white areas with a soft eraser on a drawing made with intense charcoal hatching, we can produce a chiaroscuro effect in the figure, obviating intermediate tones.

A

B

These two drawings of a sphere allow us to better understand the difference between a volume rendered with modeling or sculptural effects (A) and with chiaroscuro effects (B). The former exhibits smooth tonal transitions, whereas in the latter, the contrast between the lighted and shaded areas is more pronounced.

A strong contrast between light and shaded areas at the expense of modeling produces a dramatic, surprising effect in the figure.

Sharp and Smooth Contrasts

The group of chiaroscuro values employed in a drawing constitutes a spectrum, within which we can choose a lighter or darker tone, or accentuate the contrast between the values closest to white or black. The spectrum of tones that appear in the drawing affects the intensity, harmony, and atmosphere of the composition. A wide spectrum with a large number of intermediate tones is more fertile and visually attractive, but if it is too rich, there is a danger of breaking up the unity and harmony of the whole.

Light and Dark Areas

In a chiaroscuro, the light areas must always be free of pigment, but if we make a mistake, we can partly recover these areas with a soft eraser. The darkest areas should also be given special treatment. Once we have achieved an intense tone, we leave the area definitively and do not touch it again, to avoid reducing the absorbancy of the paper, which would make it impossible to achieve a darker tone, no matter how hard we try.

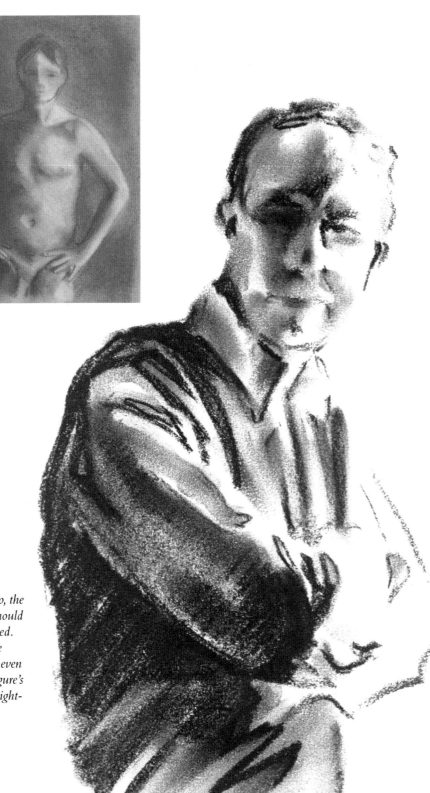

In a chiaroscuro, the lighted areas should be left untouched. Notice how the strong lighting even dissolves the figure's outline on its right-hand side.

THE CLOTHED

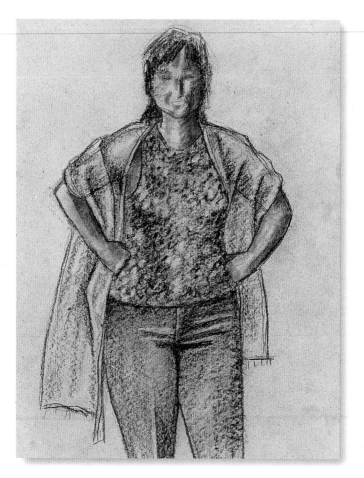

Esther Rodríguez. *Female Figure with Shawl*, 2002.
Charcoal pencil.

Human Figure

The study of the figure should not be relegated to drawing nudes. We shouldn't forget clothed figures depicted in everyday situations. For the amateur artist, this subject presents from the outset a simpler rendering solution than the nude, because clothing obscures the model's anatomical reliefs and muscular profile. The goal is not only to draw a well-proportioned body and the posture it assumes, but also the draping of its dress, and the creases and folds that it produces. Furthermore, the clothing that dresses a figure should be represented convincingly: if the model raises his arm, the wrinkles in his jacket should match the limb's motion.

STUDYING *the* INNER STRUCTURE *of the* BODY

Perhaps the hardest task for the amateur artist drawing the clothed figure is representing the form hidden underneath the clothing. In a clothed figure, the problems that arise have to do with the quality of the textiles of the clothing, with their wrinkles and curved surfaces, which make it difficult to understand the pose or attitude that the body assumes in certain situations.

Understanding the Structure of the Figure

As with the nude human figure, it is necessary to understand the model as an organic whole, but with a clothed figure we have an advantage in that, if a part of the body remains hidden or seems confusing, we can try to imagine its inner structure, the position that the limbs adopt in a nude pose. To do so, it helps to draw simple geometric shapes that constitute the drawing's infrastructure. From there, the goal is to adapt the clothing to the model. Very few garments reveal the details of the anatomy, so the form of the body and the wrinkles are determined by the type of garment worn by the figure and the weight and rigidity of its fabric.

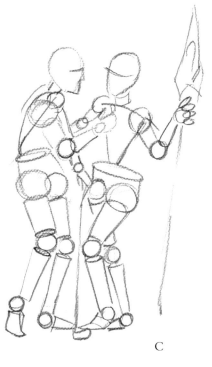

We should approach the clothed figure with a similar outline to one we would use for a nude, ignoring the folds in the clothing and looking instead at the pose in its entirety.

If the figures in the drawing are wearing loose clothing, it may be difficult to visualize their inner structure (A), and for this reason it will be of great help to the beginning artist to imagine the model nude, and try to discover from each pose each of the positions of the limbs (B). If "undressing" the figure is too complicated and we are unable to guess at the limb's terminals on the basis of the folds they create in the clothing, we can turn to a geometric sketch, and try to understand the body on the basic of simple volumetric shapes (C).

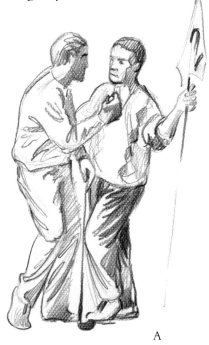

A

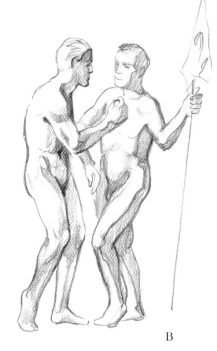

B

C

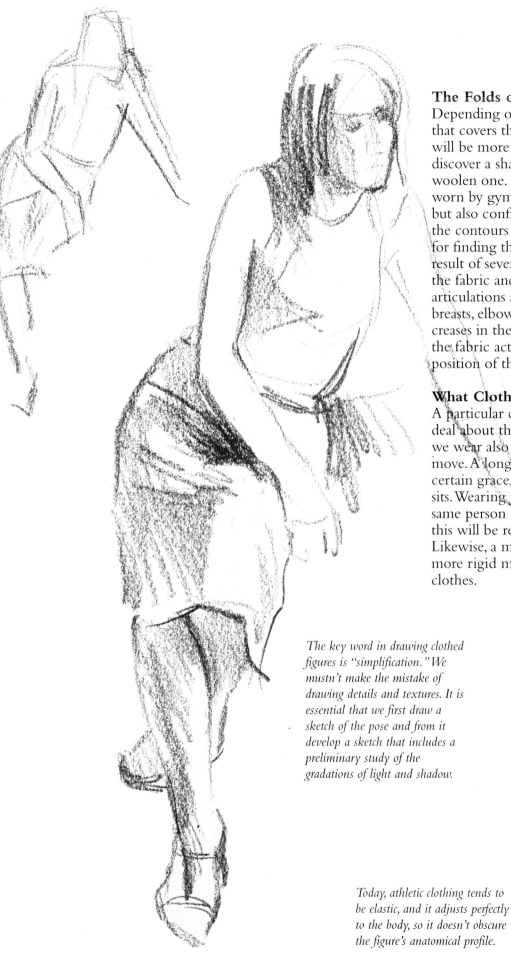

The Folds of the Joints

Depending on the type of garment or fabric that covers the body, the motion of the figure will be more or less evident: it is easier to discover a shape underneath a silk dress than a woolen one. Elastic garments such as those worn by gymnasts or cyclists, mold the body but also confine it. The folds in the clothing and the contours of tight garments are a good index for finding the body's volume, as well as the result of several factors, such as the rigidity of the fabric and the play of the body's articulations and joints. Keep in mind that the breasts, elbows, and knees are suggested by creases in the cloth; the wrinkles and tensions in the fabric actually explain the bends and position of the limbs.

What Clothing Reveals About Personality

A particular clothing style can tell us a great deal about the person wearing it; likewise, what we wear also influences the way we feel and move. A long, loose dress gives a woman a certain grace, and this is reflected in the way she sits. Wearing jeans and informal clothing, the same person will feel completely different, and this will be reflected in a more relaxed pose. Likewise, a man in a suit and tie tends to sit in a more rigid manner than one wearing informal clothes.

The key word in drawing clothed figures is "simplification." We mustn't make the mistake of drawing details and textures. It is essential that we first draw a sketch of the pose and from it develop a sketch that includes a preliminary study of the gradations of light and shadow.

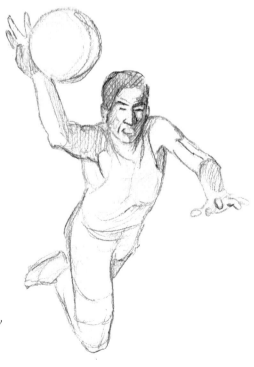

Today, athletic clothing tends to be elastic, and it adjusts perfectly to the body, so it doesn't obscure the figure's anatomical profile.

CLOTHING *and* FOLDS:
CREATING TEXTURAL EFFECTS

Notice in this series of drawings the different hatching possibilities for reproducing clothing by depicting its creases and textures. The first treatment of the figure is the sketch, and there is nothing better than using the flat side of the chalk to obtain synthetic hatching effects. A few strokes are enough to mark the direction of the creases.

The most important aspects of the clothed figure are the draping of the garment and the types of creases or wrinkles that it forms. A towel, jacket, shroud, or silk dress looks very different from bare flesh.

Drawing Creases

Drawings of clothing, fabrics, and ornaments of any kind present a serious challenge that merits discussion. The creases that envelop a figure can appear thick and rigid or subtle and vaporous, revealing the forms of the body underneath. Lighter fabrics such as silk or cotton create many small wrinkles, and they usually present very fine tonal values; velvet and wool, on the other hand, produce more rigid, separate wrinkles. The creases and folds of thin, translucent fabrics are softer and more numerous; heavier fabrics have fewer and larger folds. A good exercise is to make studies of wrinkled garments that you find in your drawer; by doing so, you will see for yourself that every fabric has its own, distinctive properties depending on the quality of their folds, how they fall, and the degree to which they absorb or reflect light. The important thing is that your pencil respond to the sensation of the material on the clothed figure.

For a more detailed drawing with chalk, we can use the small tortillon to expand and gradate the grays. To draw wrinkles correctly, we should be aware that they produce shadows, and that they also show "crests," areas on which the light falls directly.

Clothing and Anatomy

The tendency to use synthetic materials in the manufacture of all kinds of garments creates many varied shines and reflections to render in drawing. Even the wrinkles or creases created by loose-fitting athletic clothes are typical of the artificial materials they are made of. Tight clothing cannot hide anatomical defects. A too-high hipbone, disproportionate arms, or poorly drawn feet will be immediately noticeable. Tight clothing tends not to show wrinkles and describes the anatomy perfectly, by revealing the profile, and because the muscle mass can be seen through the garment. Loose-fitting clothing, however, hides the anatomical relief of the body and shows more folds. Wrinkles produce shadows, and in their crests, areas on which light falls directly. This creates the need to analyze the tonal values and carefully nuance every surface more meticulously than tight clothing.

To analyze the folds of an item of clothing, it is a good exercise to first make a linear treatment of the figure, drawing all of its wrinkles as contours. In this way, we will confirm that the fold also varies depending on the material with which the garment was made.

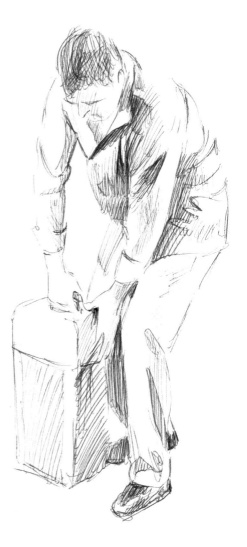

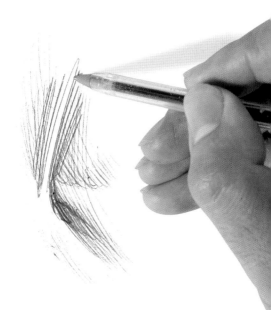

Graphite pencil is the most appropriate medium for delicate work. We can mark the limits of shaded areas and fill each of them in with gray hatching. It is necessary to grade and nuance every surface, sometimes very meticulously, because the gradations of a graphite pencil are very fine in most cases.

The ball-point pen is perhaps the least noble of all drawing instruments, but it is nevertheless frequently used by professional artists. Its strictly linear properties force the artist to make hatching on clothing based on stretches of overlapping lines.

The DRAPE:
RHYTHMS *and* WRINKLES

The traditional complement to the volumes of a nude figure is the drape and the folds and creases that it produces. Its function is more than simply anecdotal: it is a formal counterpoint that allows one to harmonize and accentuate the forms of the nude, adding a touch of color to enliven the composition, if necessary.

Drawing the Drape

Drawing the drape is another academic discipline, out of fashion today, which drawing students were traditionally expected to master. It consists of drawing in pencil or charcoal the folds and the general form of a cloth hanging or falling over a chair or stool. The purpose of this exercise is to exercise the student's skill in rendering light and shadow, and in creating a complicated and detailed volume. Drapes are also interesting from a compositional point of view, because if necessary, they allow for a balancing of the pictorial space by compensating the excessive weight of the forms of the figure through the crisscrossing of their folds.

To represent a drape convincingly, we must work carefully on its modeling by making subtle gradations and opening up stretches of white for the highlighted areas.

The rhythm of the trace as it comes and goes can be used to render a drape while also creating an attractive zigzag effect. Zigzagging lines can suggest creases and folds rhythmically and fairly naturally.

Abstract Drawing

Drawing the drape can be considered an authentic abstract drawing, given the geometric complexity inherent in the folds and their independence from the figurative forms. In this sense, it is interesting when drawing the drape to find that the problems of line, chiaroscuro, and modeling are nakedly evident here. The exact construction of folds and their shadows is inessential; it is more interesting to interpret drapes in an abbreviated, sketchy manner, in agreement with the characteristic lightness of these secondary elements of a figure drawing.

Although you may see this as a complex problem, do not be discouraged. Look at the object as an abstraction and reduce it to simple forms and surfaces. The key is to observe the way that clothing falls and adjusts to the forms of the body. It is a matter of training your eye to appreciate the structure and form of wrinkles with clarity, as a whole and individually. This coherent vision allows us to see it all clearly: a tucked-in part here, a protrusion there, over here a broad concavity, etc.

Drapes are a very attractive complement to both clothed figures and nudes. They add a very mannered decorative effect that recalls the zigzags of an arabesque.

If you observe the drapes and creases of clothing in isolation, you can look at them as an abstract composition. The most important thing is to consider their structure and not forget the direction of the clothing: curved, heavy wrinkles (A), and straight, vertical creases (B).

A

B

If you are drawing a figure with many creases, you may choose to structure the information. The first step is to make an outline of the model and work with simple forms indicating the form and position of each crease. Then, patiently, extend the hatching that accentuates and gives volume to the area.

The FIGURE
and ITS CONTEXT

Most spontaneous figure drawings are taken from everyday life. All you have to do is observe the figure at home, on the street, or at work, and find its pictorial aspects. In fact, one of the most interesting subjects for drawing studies is the interiors of public buildings—bars, restaurant, cafeterias, dance halls, etc. In these surroundings, figures appear in more natural poses, revealing their character and sociability. Drawing the background in which you find the figure is of great help in drawing the figure later.

Drawing Architecture

Drawing figures in an interior often involves dealing with the perspective of the setting. But perspective need not be a problem, for it, too, can be used to establish a clear background, and thus the comparison of the size of the figure with the objects in the background can be extremely practical in achieving a realistic representation of the figure itself and its surroundings.

This variation is of particular interest: the participation of architecture in the composition of the relationship between the figure and the decor can be so significant that to ignore it is to deny the drawing what could potentially be one of its most notable traits.

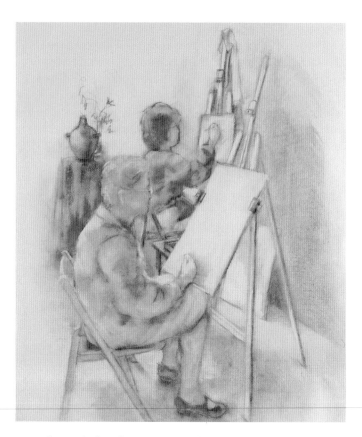

If instead of working in strokes that clearly delineate the figures' contours, you draw them with a blurry, atmospheric outline, you achieve a greater integration of the figure and its background.

Perspective is a key factor in representing figures in context. In scenes such as this one, make note of how the figures grow smaller and grow progressively discolored the further they get from the foreground.

Concretion and Indeterminacy

The figure is generally rendered concretely while its surroundings are left sketchy and indeterminate. Its concretion doesn't necessarily mean well-defined contours, but rather a more intense line (a very common error among beginners is to draw a definite contour around the figure, and thus detaching it completely from the background). Light conditions can make it so that parts of the figure appear to meld into the background, and part of the success of a drawing depends on softening its margins and omitting details, leaving some things to the viewer's imagination.

The background that contextualizes the figure may include just a few lines or marks, but there is almost always some indication that something more lies behind them.

To draw quick studies, a graphite pencil is among the most recommended mediums. A graphite pencil gives us a variety of strokes: drawing with a sharpened point (A), a dull point (B), or with the point completely tilted onto its side (C).

A study of figures in an urban landscape is no easy task, for the figures are never still. This forces the artist to be selective, draw in synthesis, and pay attention, basically, to the attitude of the model and to the objects around him.

The profile of the closest figures shows more intense, pronounced lines, which helps to differentiatethem from the background.

Textures AND Effects

"With effects, blending and smoothing, anything suggesting immobility, stability, gravity, density, and firmness, disappears and is diluted in the fluid and intangible—a luminous vibration that translates all the appearances of the world."

Moniteur des Arts, 1863.

THE ARTIST'S

Marta Bru. *Female Figure with Intense Lighting*, 2002. Charcoal.

Resources

When drawing the human figure, one of the artist's biggest challenges is to express and represent the various textures and tones found on the human body, such as skin pigmentation, wrinkles, and body and facial hair. To do so, the artist need rely solely on the basic drawing techniques of line, blending, volume, erasing, and gradation—all of which can also be applied in drawings to create atmosphere—to achieve his or her artistic interpretation of the human model.

RENDERING *the* ATMOSPHERE AROUND *the* FIGURE

The atmosphere of a drawing depends on the harmony that dominates the scene and evokes a determinate sensation of light, a factor of artistic quality that is important to observe.

Nonetheless, apart from the intensity and quality of the lighting, there are other factors that condition the atmospheric climate: the intonation of colors, the chiaroscuro effect, contrasts, a greater or lesser use of modeling, etc.

If we blend grays into each other, eliminating any intense traces, the figure loses definition but gains atmosphere.

Faintly defined, diffuse profiles made with soft lines integrate the figure to the white of the paper, giving it an atmospheric effect.

Drawing the Air Around the Figure

The atmosphere should be present in the work as an air surrounding the figure. The effect of atmosphere is an optical illusion produced by water vapor and the dust particles in the air, which discolors and partly blurs the forms and profiles of the figure. This is the opposite of the hard contours and precision of the drawing. The atmosphere should be fluid, continuous, unified, and uninterrupted. The absence of clarity is the key. With a correct tonal evaluation of each of the drawing's planes, we can recreate in them a lighter or denser atmosphere, deciding on the basis of the intensity of its tones what spectrum of grays should occupy each plane.

To achieve an atmospheric effect, the grays and tonal gradations should be blended and smoothed out, with no visible strokes, and soft transitions between tones.

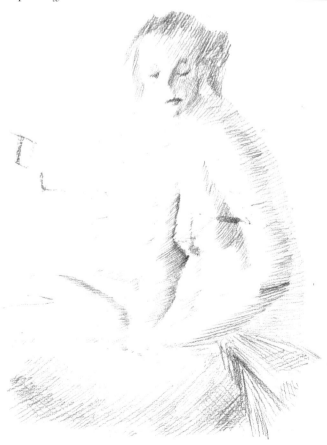

Atmospheric Hatching

An atmospheric effect depends above all else on our skill during the hatching process, as we increase the pressure on the charcoal, pastel, or chalk and impress its stroke upon the paper. The goal is to shade or to color, passing gradually from a lighter tone to the next darker one, and so on. Each phase should be accompanied by a light fingertip blending to avoid abrupt shifts in tone.

Blending

The difference between smoothing and blending lies in the purpose of each. Both operations require that we run an object—a cotton rag, a fingertip, etc.—over a spot of pigment on the page. But smoothing is intended to withdraw and extend color, whereas the purpose of blending is to mix the different tones by repeatedly rubbing the color. With blending, the hatching or coloring also grows softer, but not as much as it does with smoothing.

The Hazy Drawing

Charcoal is the ideal medium for producing a hazy drawing. This term refers to making very subtle tonal gradations, describing forms without drawing contours or outlines. This technique, which produces very foggy, obscure figures, consists of insistently rubbing the surface of the paper with one's fingertips until the figure's appearance becomes vaporous and atmospheric. The absence of visible pencil strokes imbues the drawing with pictorial finish.

The haziness of this drawing gives it a pictorial quality. The effect is achieved by insistently blending the grays.

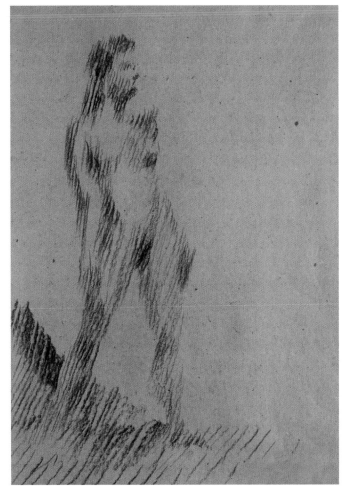

Charcoal is used a great deal in atmospheric drawings because it mixes and blurs easily and possesses rich tonal qualities.

Atmospheric figures can also be achieved through lines, but the lines must blur and obscure the profile of the figure, breaking down and obscuring its principal shapes.

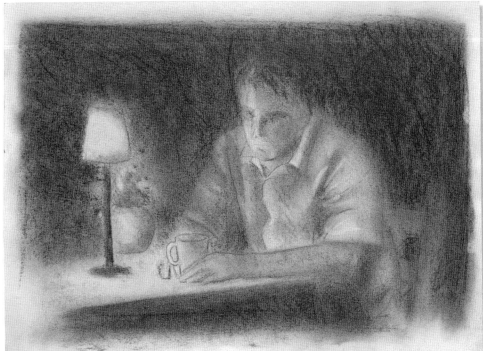

CREATING VOLUME
with ACCENTS

Using white chalk on colored paper is one way to create accents, but mixing white chalk with other colors or with charcoal allows for more intermediate tones. In creating accents, we can play with the interaction of three different factors: the tone of the paper, the use of charcoal or colored chalk, and the use of white chalk. We can therefore increase the range of tonal values, which are used to create volume in the figure.

Accents in White Chalk

An accent is the addition of a tone much brighter than the paper and the other media used. When we draw on a colored background, the tones we can make with the charcoal or chalk are limited by the medium and by the color of the paper itself. Nonetheless, this problem can be overcome by adding touches of white; the contrast is then so sharp that the drawing becomes newly interesting.

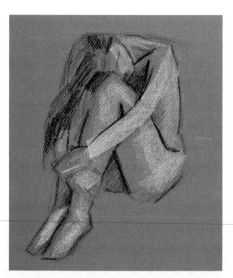

White accents give the figure a more volumetric appearance, because they accentuate the contrast between its lighted and shaded parts. In studies and sketches such as these, accents can be made using the flat side of the charcoal or chalk.

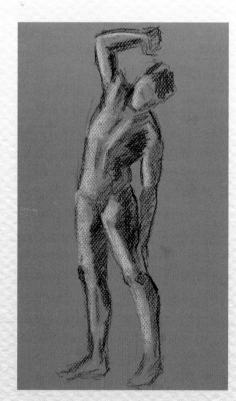

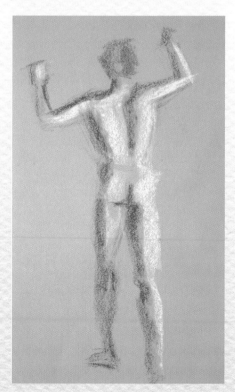

White chalk combined with other colors can provide the drawing with a much broader palette if used on a colored background.

White chalk can also be combined in a single drawing with charcoal. If we want to practice tonal gradation, we first extend the charcoal hatching and then superimpose marks made with chalk—never the other way around.

For more precise accents, it is preferable to use white colored pencil instead of the traditional chalk or pastel.

Lighter Gradations

To create a gradation between charcoal and white chalk, we first draw with chalk from one side to another, applying less pressure with each pass, and then shade this layer with charcoal, but this time we apply the most pressure onto the charcoal where the least pressure was applied to the chalk, and vice versa. However, it is not the same thing to apply charcoal to chalk as to apply chalk to charcoal: a different result is produced depending on the order in which they are applied; only with practice does one grow accustomed to their interaction.

Accent Effects

Accents in chalk can be applied in swaths of lines, with dense stains of light in the form of points, or by dragging the chalk over a given area, so that it acquires a greater general brightness. Accents have no effect when they are dispersed gratuitously over the entire surface of the drawing; they only stand out when they are concentrated in those parts of the drawing that help produce an increased contrast and accentuate the volume of the figure. On some occasions, it may even be necessary to add a light hatching around the accent.

Delicate work should be done in white colored pencils, because with them it is possible to make both sharp lines and suggestive hatching. By varying the pressure that you apply to the pencil, you can distinguish the intermediate tones from the points of maximum brightness.

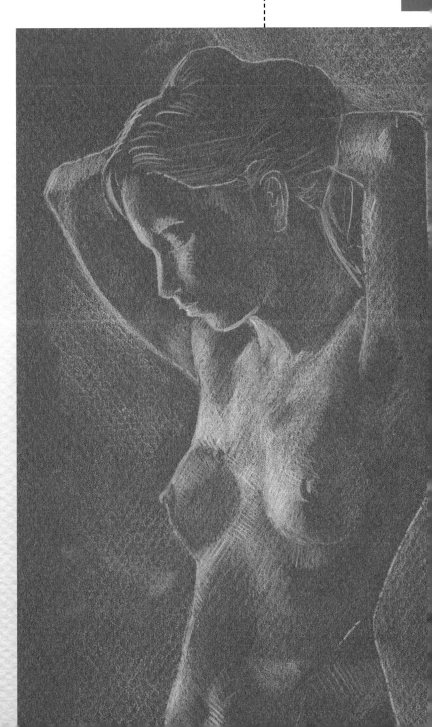

CORRECTING
Without ERASING

During the process of its creation, the drawing undergoes constant changes, to the point that the initial outline serves only as a perch; it is therefore important for the artist to transform the work constantly, each time establishing more forcefully the line that constitutes the drawing's planes and forms.

As the final profile of the drawing begins to take shape, the lines that constitute it begin to overlap with earlier lines, in such a way that the process can be seen as a continuous correction of forms, until they overpower the earlier lines, making it unnecessary to erase them.

The Mistake as an Expressive Factor

In the work of many professional artists, corrections and repetitions are deliberately left in the final drawing as a practical resource that lends vitality to the drawing, or even suggests action or movement in the figure; these corrections are known as pentimenti, or regrets.

Pentimenti express a strange fascination with unfinishedness or sketchiness, and with the process of drawing itself, rather than the carefully finished product, a tendency that reveals the romantic in all of us. Therefore, when we make mistakes it is preferable to forget about them and draw more precise, vigorous lines alongside them. Every drawing should be an experimental, ever-changing process. To try out a form tentatively, and then make adjustments and corrections to it—these are fundamental parts of every creative process.

Charcoal makes it possible to erase the figure repeatedly in order to add new lines to modify the previous ones; however, in this sketch, the earlier marks are still visible alongside the new ones.

Phantom Lines

Drawings in charcoal are made by
adding one overlapping line after
another, which are erased or
corrected over the course of
creating the drawing. This
accumulation of discarded lines—
"phantom" lines—creates an
interesting tonal effect on the
foundation of the page, and
sometimes even lends a greater
expressiveness and adds variety to
the drawing. The result is a few
confident, powerful lines that
emerge from what has, in fact,
been an intense process of
drawing and redrawing.

*Some artists use pentimenti as
another means of expression. In
this case, the simultaneity of the
legs gives the figure a sense of
motion.*

An Intuitive Drawing

The continued practice of drawing
the nude eventually gives the artist
an intuitive knowledge of the male
and female anatomies, which allows
her to render virtually any pose
automatically and render all of its
reliefs in their correct place and
proportions. This knowledge is
gained by noticing and correcting
the mistakes one makes, and by
always keeping in mind the basic
sketch of proportions and the
body's essential anatomical
configuration.

The complete
erasure that is
often practiced in
the early phases
of drawing with
charcoal is
actually done to
create phantom
lines that serve as
a base for the
next stage of the
drawing.

*Pentimenti allow us to understand the study as a
living, creative process in constant development,
which forces us to select and make decisions about
the correct placement of the limbs in each pose.*

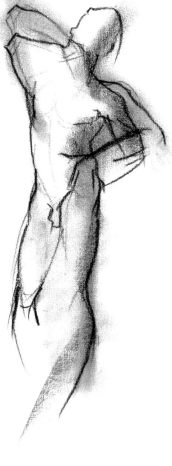

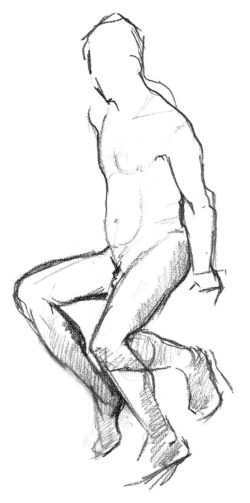

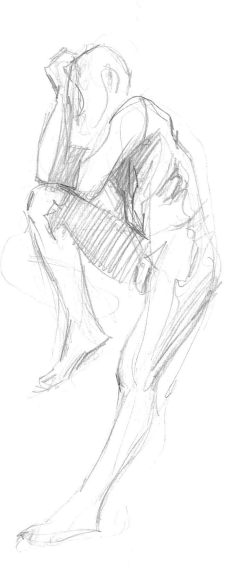

*New lines are superimposed on the initial
ones, and modify the figure's appearance until
the desired pose is attained. When working on
a study, lines are seldom erased, which allows
us to see the process that the figure has
undergone from the start (in the study at
right, it is still possible to see the preliminary
position of the legs and back).*

BLENDING

to DISSOLVE CONTOURS

Astump, or tortillon, is a stick made of soft, absorbent paper with a point at either end, used to rub and blend tones, to produce a graying or lightening of areas drawn in pencil, charcoal, pastels, or chalk. Cotton balls or swabs can also be used for blending and produce smoother, more subtle results than the tortillon.

The Correction Effect

Stumping is in itself almost a form of correction. What we are in fact doing when we use a tortillon is removing dust that would otherwise adhere to the paper. This type of correction changes the effect of the line and can even eliminate it altogether. Stumping can also be used to fill holes—those areas that were previously free of charcoal or chalk. This reduces the paper's capacity for more hatching or coloring in later applications.

Blending with one's fingertips, if done insistently, can lighten the hatching made with charcoal.

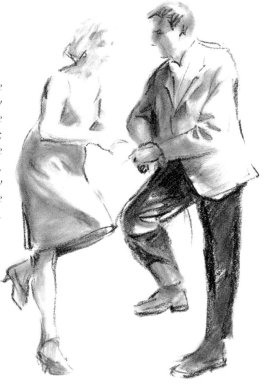

These figures were created entirely by stumping lines made with maroon pastel; afterward, to give the figures more corporality, we have added a few lines that underscore their profiles.

Opening White Spaces and Blending Lines

The charcoal stick can be smoothed with a tortillon, fingertips, or a paintbrush. When charcoal is smoothed, it becomes lighter; this is almost the only way of creating gradations, because the change in intensity is barely noticeable when one traces more or less smoothly on the paper. High-intensity soft graphite can also be smoothed with a tortillon, which allows lines to be integrated and eliminates the white spaces between them. By grading the tones, the tortillon creates a perfect representation of an object's volume. Any rubbing technique can be used to smooth the lines of this instrument, but it is ill-advised to overuse this technique because it can drain the final drawing of its liveliness.

Two Ways of Smoothing

There are two basic ways to practice smoothing. To soften the heavy lines or profiles of a model, we should use the tip of a tortillon. To smooth out large areas, we use the wide part of the tortillon. The motions of the hand should follow the volumes of the body. When working on imprecise foundations or smooth surfaces, the hand should make a circular motion.

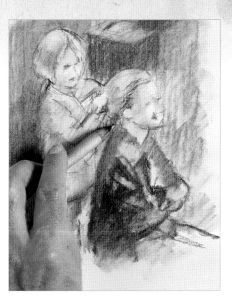

Smoothing is a process that allows the artist to model the fleshy parts of the figure by making smooth transitions in tone that help to explain the volumes and relief of the human body.

When making a study, a few grays and a swipe of the tortillon are very useful for differentiating lighted areas from shaded ones.

It is worth noting that the possibilities of stumping increase when you use vine charcoal instead of compressed charcoal in stick or pencil form.

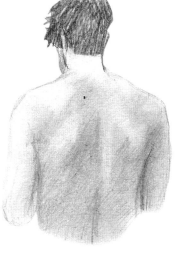

Smoothing not only creates subtle tonal effects, but also gives the surface an attractive texture. Use it to endow your figures with depth and brightness.

ERASING:

OPENING UP SPACES

The eraser can play an important constructive role in drawing the human figure. It serves as a drawing instrument in itself, useful for working with the quality of the line and tone. We can use it to clear an area, smooth out a line, or draw in negative, drawing the outline of the figure by erasing on previously colored areas. In the same way that we can produce different qualities of blacks depending on the pressure we apply to the charcoal, the eraser allows for an inverse of the same technique; the more pressure you apply, the whiter the erasure will be on the page. If the erasure is soft, when the eraser passes softly over the coloring it smoothes it out lightly. An erasure shows us how we can construct a form using bright lights on a darker background.

An eraser can be used for more than correcting errors: we can use it to lighten and model the relief of the body.

Dexterous use of the eraser raises the volumes of the body, helping to create an effect that reminds us of Greco-Roman bas-reliefs.

Once the tone is spread out, we trace the outline of the figure using an eraser and mark its bright spots by applying greater force as we erase.

Creating Effects with an Eraser

We can achieve various different effects with an eraser. Using one of its sharp edges, for example, we can create thick lines; if we rub the entire width of the eraser on the paper, we can make a broad swath; and we can make fine lines by tracing with its edge or using a retractable eraser. Retractable erasers are very useful for drawing on a previously colored or shaded surface. In diffuse drawing, the shine of the skin is reinforced by opening up white areas with the eraser, as well as by modeling forms and respecting those areas that automatically create shadows. Finally, we can give greater nuance to the sharpest of contrasts by softly applying a pencil or chalk and following the form of the anatomical surface.

Working with Charcoal

The limited adhesiveness of charcoal makes it very hard to erase. In these cases, a soft gum eraser is essential, because not only can it be used to correct mistakes, but it is also useful for opening up white spaces within a hatching or blend to restore the color of the paper even after it has been drawn upon.

The malleability of charcoal makes it one of the best bases for a drawing based on erasures, whether it's textured or smooth. An eraser can also be used as a blotter of sorts, creating textures and repeating a previously modeled figure on dense charcoal hatching.

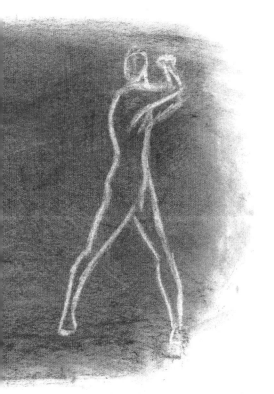

Erasers are also a drawing instrument. They are a medium for working with the quality of a line on a colored background.

When the eraser is rubbed softly on a hatching or coloring, it smoothes it out lightly. If we use this effect carefully, we can suggest the middle and darker tones.

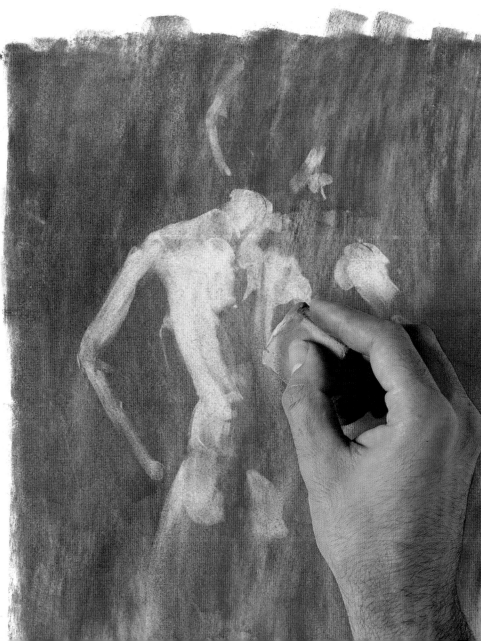

EXPRESSIVE LINES:
RHYTHM *and* TENSION

The interpretation of the model with expressive lines emphasizes its formal properties and imbues the drawing with character. A drawing need not only refer to representations and structures in the physical world—it can also express some of the personal traits of the artist: his emotions, imagination, perceptions, and personality. The abstract qualities of form, rhythm, and color always have an emotive response for a perceptive artist.

Expression in the Figure

Expression is a difficult concept to define in a few words without giving rise to ambiguity. A figure drawing is expressive when it possesses "life," an inner vitality; when the model appears animated and is not reduced to pure, cold representation. Expression can be achieved in several different ways: by using saturated colors; with intense, out of control lines; or through formal distortion.

In order to properly make an expressive drawing, it is useful to practice the graphic quality of the line itself, and study its intensity and direction.

Mastering line is an essential skill when drawing a study from life, especially if we consider that in many cases, it is necessary to work quickly because postures are often fleeting.

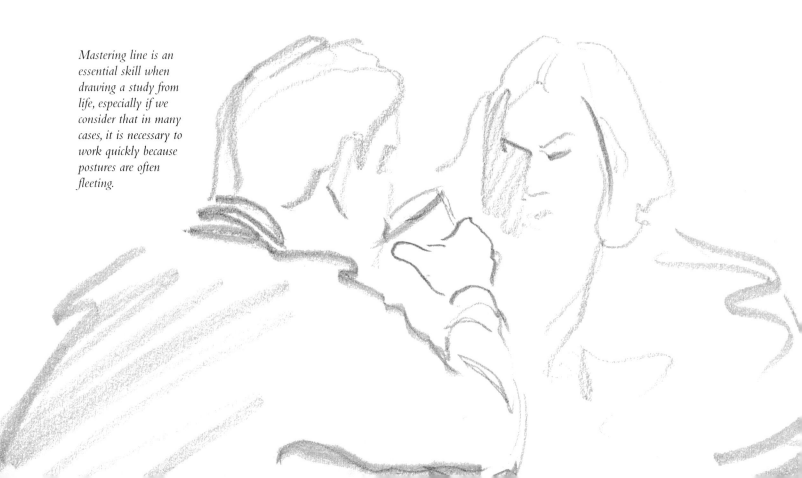

Linear Marks

To achieve an expressive line in our drawings, we must work quickly, and barely lift the pencil from the page, or shade, and follow the main lines of the subject with a loose, carefree, nervous stroke of the pencil. Expressiveness is manifested thanks to perceptual quickness and unconscious work, which allows for the improvisation of lines with a liveliness and strength that are impossible to produce with a slower, more methodical execution.

In this type of drawing, lines are expressed quickly, and the form is captured and represented in its totality, with no details, but in its full, dynamic action. Its features are decisive and the pressure applied to the line varies depending on the emotional reflexes of the artist; the line is decisive and flexible if we can lose ourselves in the impulse of a fleeting perception.

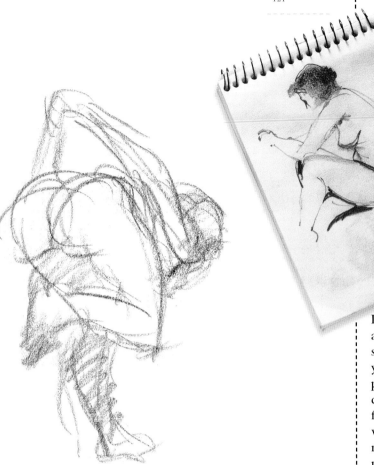

Expressive drawings are the most appropriate for transmitting the motion of a figure. The lines in this kind of sketch overlap, creating terrific structural confusion.

It is advisable to always carry a sketchbook with you. By observing people and drawing them frequently, you will build a visual memory of physical forms and expressions, and you will gain practice in using a quick, spontaneous stroke.

Making expressive strokes forces us to render the line very quickly, disregarding the details and instead focusing on the rhythm and structure of the figure.

To make an expressive drawing, it is better to work with the pencil point tilted slightly, which gives the line greater presence and modulation.

Hair is a malleable covering. It varies greatly depending on a person's race and comes in a wide array of forms and textures that can be a challenge for the amateur artist. Hair can be represented in three ways: first, drawing in synthesis, while determining only the effects of light and shadow; second, rendering the effects of light and shadow, the tonal values, modeling the forms, light, and shine that determine the quality of the hair; and third, rendering the hairstyle by controlling the direction of the line.

HAIR TEXTURE

Hair Tones

No matter how dark the hair is, we must never draw it in a tone so intense that it contrasts excessively with the tones of the face. We must soften this dark color, making it as light as the most darkly shaded tones of the face or neck, to integrate the tonal values of the hair with those of the rest of the figure. Subtle variations in light and shadow help express the texture and volume of the hair. We can achieve the effect of softness with a blurry or unfocused profile or by adding a satiny shine to give the hair a silky appearance.

There are several methods for giving volume to the hair of finished figures. The most effective of these is to conceive the locks of hair as if they were blocks, and model each area separately with its own light and shaded parts.

In a quick sketch, the texture of the hair is treated only minimally; it can be rendered with a simple hatching made up of directional lines.

If we want to represent the texture of the hair, we must not forget that the pencil lines must always flow in the same direction as the hair. When drawing curly hair, for instance, the lines must be curved.

The Direction of the Stroke

The direction of the stroke must follow the logical direction of the hairstyle; therefore, we must take into account the shape of the style every time we draw the hair: with straight hair, the lines will be very straight, while with wavy hair the lines will be curved. Curly hair can be rendered with swirls, and very kinky hair can be rendered in very fine doodles. Thus, we achieve hair that seems to really originate in the scalp. On the other hand, it can also be interesting to apply loose traces to express the lightness of the hair, avoiding a solid, overly "heavy" form.

Body Hair

When drawing the hair on the brows, armpits, or pubic area, do not try to draw each hair individually. You should make these traces only articulate enough so that they imitate the texture of the skin covered in hair and the different tonal intensities that these areas exhibit compared to others. The hair on a man's legs and chest can be rendered with short, light, directional lines or by smudging of circular or irregular traces applied with a light touch of the pencil.

Lines describing hair shouldn't be uniform; it is more effective to vary their intensity and girth to describe a silky texture based on the incidence of reflecting light on its surface.

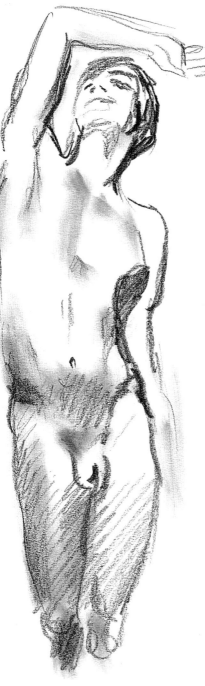

Despite its appearance in real life, hair color must never appear very intense. We must integrate its tone harmonically to that of the face as a whole, as we would any other part of the body.

There are two basic ways to represent body hair: one is to start with a classic, gray hatching, using parallel tracings; the other is to start by smoothing the hatching with a fingertip stained with charcoal. The drawing at right shows both possibilities.

The QUALITIES
of the SKIN

The skin is the outer dressing that covers the human body completely, giving the body the appearance of a single, colored surface. Although this is not altogether the case, this surface presents more or less pronounced volumes. Every individual has a unique skin color, but light affects the color through which it is perceived, creating different tonal values.

Flesh Should Look Like Flesh

When drawing a nude, the flesh should look like flesh. When faced with representing the skin, consider the following factors: the wavy reliefs of the muscles, wrinkles, the navel, and the creases and joints in the limbs, as well as the age and race of the person pictured. The flaccid, wrinkled skin of an elderly person will not look the same as the smooth, taut skin of a child; similarly, a person of color will hold different tonal varieties than a white person. The volumes of the body's fleshy areas depend, above all else, on the muscles, tissues, and the texture and firmness of the skin. A more evident, general factor to consider is the appearance of wrinkles with age, the flaccidity of the skin in certain areas, and the presence of bags, particularly in the cheeks and neck.

Skin covered with body hair should be drawn sketchily. The best thing is to attempt to create a grainy layer of vellum by rubbing the side of the charcoal stick on the page—the speckled line simulates the hairy covering of the skin very effectively.

Try to think of wrinkles and creases as definite forms and avoid representing them as arbitrary lines on the surface of the skin.

Different Racial Types

The laws of proportion or anatomy described at the beginning of the book aren't valid for everyone. The facial features of a Black person are more pronounced than those of a Caucasian; similarly, in a Chinese person, the height of the body equals some seven and a half rather than eight and a half heads. Sometimes, we find it difficult to draw faces or bodies of races other than our own for the simple reason that we are so familiar with our own proportions that our perception when drawing others becomes limited. The only solution is to face this issue and seek new models. Once you have progressed as an artist and developed your powers of observation and analysis, drawing different racial types will become easier.

Shadows and Light

The flesh tones of a nude should always be at the service of the expression of light and shadows on the anatomy. It goes without saying that shadows can be deep and dense, or soft and transparent, and that light can be intense, direct, or indirect. We must also consider that the tones of the body vary depending on the color surrounding the figure. This effect can then be attenuated or intensified by surrounding the figure with other colors that contrast with its profile. Therefore, skin color is a creation borne of the chromatic treatment of the work, and can be modified and affirmed as the drawing progresses, attenuating, correcting, or intensifying that color.

It is useful to practice drawing models of different ethnicities. In doing so, we discover that the skin may have different tonal values, and identify slight differences from the classical laws of proportion, particularly as concerns the face.

Step

BY

"At an indeterminate hour, from a source known to us today, the work of art ineluctably comes into the world. Cold calculation, spots that erupt into disorder, mathematically exact construction—clear or recondite—loud or silent drawing, scrupulous workmanship, fanfares of color or pianissimo of wide, tranquil, brittle surfaces."

W. Grohmann and Wassily Kandinsky: Milan, *Il Saggiatore*, 1959.

Step

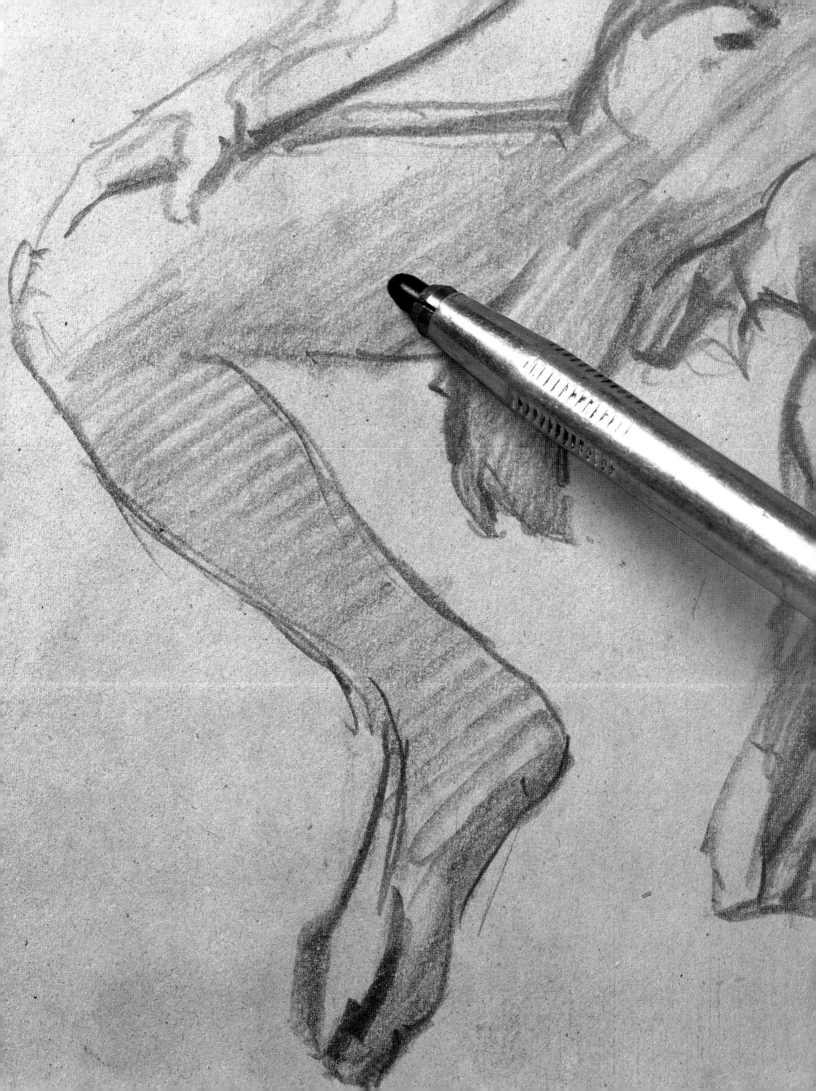

The NUDE FIGURE in CHARCOAL: The OUTLINE

The outline is the first step the artist must take on the page. It consists of drawing the formal structure of the model, taking into account its limits and proportions, as Gabriel Martin has done in this exercise. In order to make an adequate outline, it is necessary to calculate, evaluate, synthesize, sketch, and try to understand how forms are articulated. If the outline is not rendered correctly, it will be nearly impossible to correct the drawing later.

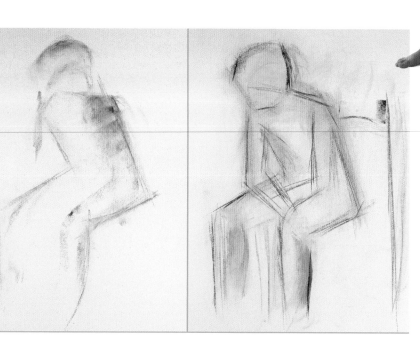

1

1. The outline should first be made with the thick side of the charcoal stick between your fingers. The basic forms of the figure are outlined very synthetically. As you draw with the charcoal stick, your fingertips should blur the initial line and blend it into the paper. In the composition, we should keep in mind the incline of the back and the zigzag composition that the legs describe in relation to the body.

2

2. The goal is to measure, erase, and correct the drawing as you go along, until, little by little, the drawing looks like the model. When, after several attempts, we find the correct line, this line should be marked as a hard incision with the point of the charcoal on the paper, which will allow you to reinforce the figure's contour.

When working with charcoal sticks, break them into smaller pieces to make it easier to maneuver your strokes on the paper.

3

3. Don't worry if you have to make corrections. To make a correct outline on the first try takes a great deal of practice; it is something you will achieve only after much drawing. Don't use an eraser when making your outline—a rag will suffice. And remember how interesting pentimenti can be.

4. The final result of this exercise is an outline that captures the posture and attitude of the model, without ignoring the correct proportional relationships of her body. The important thing here is to achieve an accurate, synthetic, firm contour line, and a drawing that doesn't get lost in the details—notice how the drawing obviates the facial features, hands, inner details of the figure, even the feet.

4

The first outline should be made with the thick side of the charcoal stick, to make the lines finer and more controllable.

BUILDING *a* FIGURE
from GEOMETRIC FORMS

Gabriel Martín proposes another way of outlining, which consists of trying to consider the forms of the model based on very simplified sketches with very few lines. There is no form or pose the human body can assume that is too complex to be reduced to simple geometric shapes. Therefore, the forms of the body can be rendered as several elemental geometric shapes that can be enclosed in a general geometric outline. This method, then, means starting from the greatest possible simplification of form—simplification almost to the point of abstraction—to render the fundamental forms of the figure.

1

1. The important thing is to capture the pose in a proportionate manner, so the first things we must draw are the lines of the shoulders and the hipbone, both somewhat tilted. We draw an oval to represent the head, a rectangle for the torso, and two overlapping right triangles for the legs. The position of the arms also describes triangular shapes. The result is a highly synthetic outline in which the pose that the figure assumes and its forms are made much more comprehensible. Starting from this sketch, we continue to add new forms detailing the volume of the body and the silhouette of the limbs with greater precision.

2

2. Once we get to this point, the drawing looks like a posable wooden model. The arms and legs are correctly insinuated. The geometric shapes are more humanized than before, which gives a somewhat robotic appearance to the figure. At this stage in the outline, we should render every part of the body completely and establish the proportional relationships between the members; otherwise, the drawing could present problems later on.

3

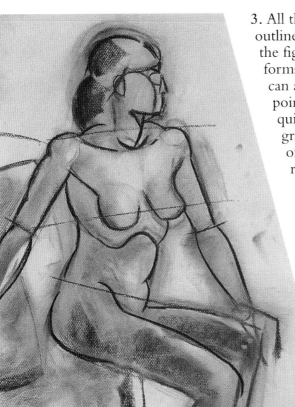

3. All that is needed now to complete the outline is to secure the principle lines of the figure, without detailing unimportant forms such as the fingers. If you wish, you can also start applying hatching at this point. This process can be done very quickly using the edge of a stick of graphite, drawing with the flat surface of the stick and then smudging the result with your hand. Make sure that the inclination of the body is correct by checking the lines of the shoulders, the breasts, and the hipbone.

Erasing a drawing completely is recommended when we intend to correct improperly situated lines; this way, we become aware of the reference points we shouldn't use, and at the same time correct possible mistakes in the outline.

4

4. In this final image we see how, when the profile is rendered with more sinewy lines and the body is modeled with hatching, the geometric outline starts to disappear, and in its place we find the body of a well proportioned figure.

Erasures in a drawing are not only useful for lightening or eliminating lines. By dabbing the surface of the paper with a rag stained with charcoal, we can achieve some very interesting tonal and atmospheric effects.

In standing poses, the lines of the shoulders and hipbone are rarely completely horizontal. Almost always, especially in relaxed poses like the one shown here, these lines assume a slight inclination so that part of the body's weight rests on one leg, while the other leg is flexed and appears more relaxed. This type of posture, as we have seen, is known as the contraposto or ischiatic position, here rendered in graphite pencil by Carlant.

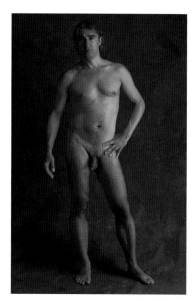

DRAWING *a* STANDING FIGURE:
The CONTRAPOSTO

1. Before starting to draw, we should make an effort to understand the body's posture using a simple, synthetic skeleton to define it. The first step is to place the oval for the head and the arch describing the backbone. In the contraposto position, the lines of the shoulders and hips always tilt in opposite directions. The first lines should have a purely constructive—not descriptive— function.

2. After placing the structural lines of the body, it becomes easier to draw the forms of the model. We begin with the head, on which we will mark the location of the facial features, then work down to the shoulders, keeping in mind that the distance from each of them to the backbone should be the same, even when tilted. Then we reach the hipbones, which tilt from the backbone at the same point at which the legs bend.

In some parts of the anatomy, the line disappears as a result of stumping, which allows smoother, more controlled gradations in the hatching.

3. Using an eraser we eliminate the structural lines that we used as a guide. The light, linear drawing from the previous stage in the drawing now gives way to the modeling of shadows (which helps us understand the forms through the drawing). But before doing so, each of the body's volumes must be perfectly defined and proportioned in relation to the rest: the height of the pectorals, the armpits, the abdomen, the pubic area, and the knees. Use the reference points of the classical law of proportions to properly situate these elements.

3

In contraposto poses, the tilt of the hips is also reflected in the knees. As a response to this tilting, one of the knees always appears somewhat higher than the other.

The FIGURE FORESHORTENED:
DRAWING *the* FEMALE NUDE

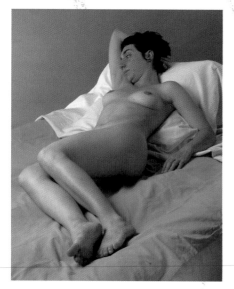

The application of the laws of proportion to the human figure is altered when the model is foreshortened—meaning, when the relationship between the body's measurements is modified by the rules of linear perspective. We explained earlier several different ways of approaching foreshortening, but the best way of learning is with practice, and by observing how Óscar Sanchis, a true professional, renders a foreshortened figure in charcoal. The technique he will use to do this exercise is to first outline the figure with geometric shapes, and then try to situate its contours by considering its countermold.

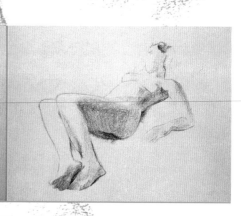

1

2

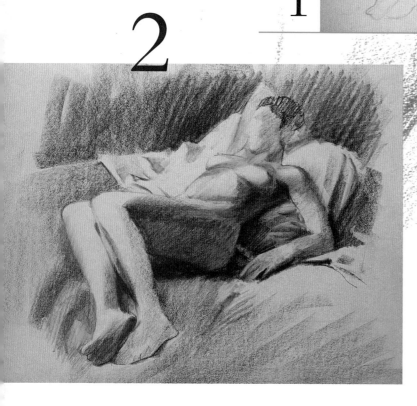

1. The first step is to establish the outline of the figure, which we begin with a graphite pencil. To do this, we make use of the by now familiar geometric outline. To draw an approximation of the model's profile we draw a soft contour in graphite pencil based on the previous outline, remembering that because the figure is lying in bed with her legs closer to the viewer, they will appear larger. The size of her head will be somewhat reduced because it is further away.

2. We continue treating the empty spaces around the figure with new tonal fields. At this stage it is necessary to emphasize the light within the darker areas of the drawing. Using crude charcoal as well as stick of pressed charcoal, it is possible to combine stains and lines of varying intensity.

3. The darkest parts of the face are made with a tortillon, with little pressure, using soft lines that allow us to find the right adjustment in tone. The purpose of blending in this drawing is to complete the scale of tones created by the charcoal hatching.

4. Complementary contrasts make it so that when they occur adjacent to bright tones, dark tones will appear more dense. The same thing happens to lighter tones, which appear much brighter when they are adjacent to dark tones.

If working with charcoal sticks, we should take the precaution of erasing, even if lightly, the graphite traces the previous drawing. The traces left by the graphite pencil are oily and will keep the charcoal from taking to the paper.

BUILDING

on STAINS

One of the most attractive ways of beginning a drawing is by using the flat stain of any dry medium in stick form, such as pastels or chalk. Its spectrum of tones is broad, but because of its color, it looks much softer than charcoal, and brighter. Let's see for ourselves the possibilities of drawing with stains by observing how Ether Olivé de Puig renders a seated female figure with sharp contrasts between light and shadow.

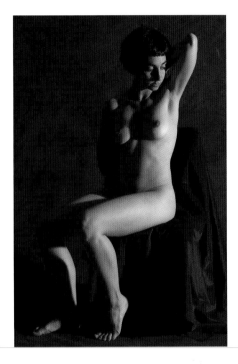

1

1. Before beginning to draw, the artist makes small sketches. If when we make the line drawing we keep in mind the line describing the backbone, in the study based on stains the lines that serve as guideposts for the drawing will be the dark areas, while the light areas will be left untouched.

2. Dragging the bar lengthwise we get a thin line; by dragging the entire width of the bar across the page, we create a thick, ample line that immediately reflects the texture of the paper. A correct use of the flat bar allows us to render complex forms in just a few moments. As we can see in this state, its interest is purely constructive. The details are unimportant; all that matters are the stains and the immediate study of the pose.

2

3. We finish constructing the figure with the length of the bar. We have not until this point used lines at all. In a tonal drawing, the grain of the paper and the pressure of one's hand give the figure its tones. Depending on the force we apply to the stick, we vary the brightness of the drawing. By not using lines, the lighted profile of the figure is defined by its contrast, and the empty space or background surrounding the figure is represented with gray hatching.

Sanguine is usually applied to textured, bone-colored paper.

3

4

4. With every new stroke, the previous layers of shadow are intensified. The spots are especially intense in the left-hand side of the body: the darkest shadows appear on the arm, the abdomen, the head, and the neck. At this stage, we combine the maroon stain with some stronger defining lines. Using the point of the stick makes it easier to trace the final lines that define the figure's profile. In the preliminary sketches, it is necessary to pay as much attention to the dark areas as to the parts of the body with intense whites.

FIGURE *with* CHIAROSCURO EFFECTS

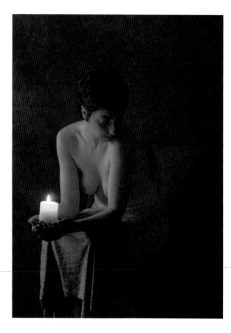

Once the outline and the preliminary sketch are done, we can now examine how to properly shade the figure. The first thing we must take into account when drawing a figure with chiaroscuro effects is that light does not envelop the entire body equally. One part of the body is exposed to the rays of light, and it is here that the lighted area occurs, while the other part of the body appears in shadow. To give shape to this idea, Oscar Sanchís uses a burnt sienna pastel, which is sufficiently soft to give its line a good darkness against colored paper.

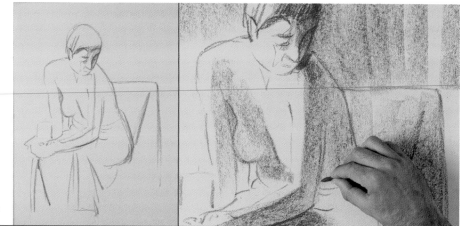

1

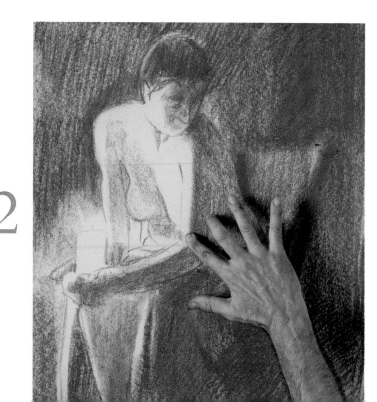

2

1. The sketch of the model should be complete before situating the lights, because the shadows should be applied on a perfectly constructed sketch.

Shadows are distributed uniformly using the flat side of the bar to mark off the lighted surfaces, without applying excessive pressure, but allowing for separation between objects and establishing the middle tones in the drawing.

2. Alternating between the flat of the bar and the lines, we darken the previous hatching. For a comparison of the different contrasts that appear on the paper, we can appreciate the darkest tone that floods the background; the brightest, which is represented by the color of the paper itself; and the intermediate tone, that of the first, soft lines of the first layer.

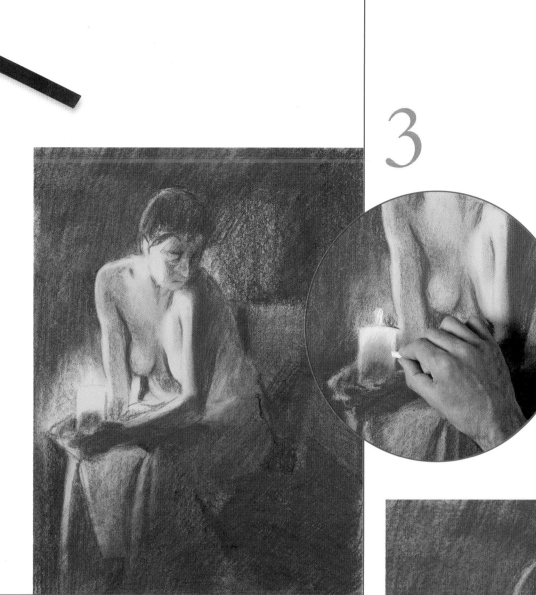

3

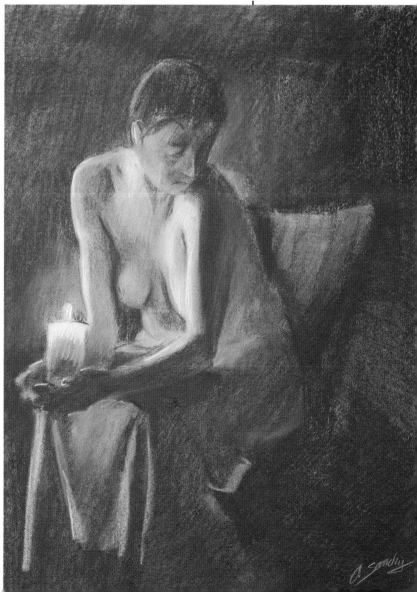

To create accents, we can sharpen a piece of white chalk with a cutter, giving the chalk a point suitable for drawing finer, more precise lines.

3. Using the flat of the pastel again, we finish extending the background tones so that they surround the figure and create the atmosphere and chiaroscuro effect. The lighted areas appear almost untouched, the same color as the paper.

To accentuate the brightest bursts of light coming off the candle, we color the lighted area with white chalk and thus emphasize the effect of radiant light. If we apply this effect indiscriminately throughout the painting, we can lose the luminous effect we were striving for.

4

4. The final result shows that chalk can offer a great tonal richness that stretches the limits of pictorial quality. We have given nuance to the final texture by using a tortillon to smooth out the transitions in tone and the edges of the shadows.

The MALE FIGURE

from the WAIST UP

In this exercise we will work through drawing a male figure from the waist up using charcoal and white chalk. The combination of these two materials will allow us to study the incidence of light on the torso and the application of a first modeling, albeit a very structuralist one. The author of this drawing, Esther Rodríguez, shows us how to render the anatomy and the play of light and shadow on a human torso in a very effective, synthetic way, without tonal transitions, which can be of great use to beginning artists.

1

2

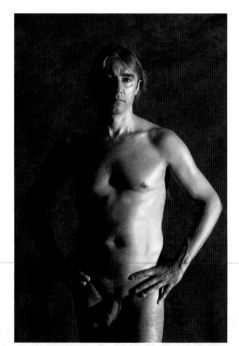

1. Begin by drawing the outline with a stick of charcoal, keeping in mind the tilt of the shoulders and hips.

3

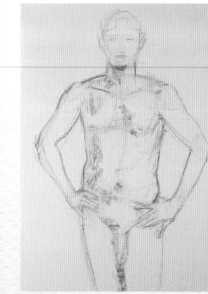

2. The sketch should give way to a first, albeit tentative, tonal analysis with shadows; but before this is done, each of the elements of the figure should be perfectly well defined and proportionate in relation to the whole.

3. With the drawing secure, we can begin to add the first darkened areas. These will allow us to study the anatomy more deeply and accentuate the areas that are exposed to light. The light source is on the right-hand side, so we should begin drawing the dark areas on the left with the charcoal stick laid completely flat.

4

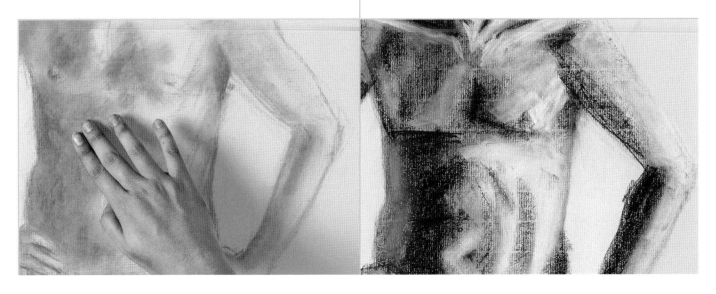

4. We must smooth the hatching and control the spreading of the charcoal with our fingers, producing great swaths of tone. Smoothing tends to connect different parts to each other, and thus achieves a unity in the figure and soft modeling on the reliefs of the body.

Starting from the previous sketch, a new study of the modeling allows us to analyze the figure's musculature. We draw the figure's lighter tones with a stick of white chalk. In this way, the spectrum of tones is broadened to include both the lightest and darkest of grays and the intermediate grays as well. White chalk should be used sparingly.

5. Use the tip of the charcoal to make sharp lines that define the figure's profile and contrast the hatching of the face, neck, and pectorals. The direction of the light should be studied carefully so that all shadows are situated opposite the main light source.

When smoothing a charcoal hatching, use your fingers to vary the intensity of the tone.

5

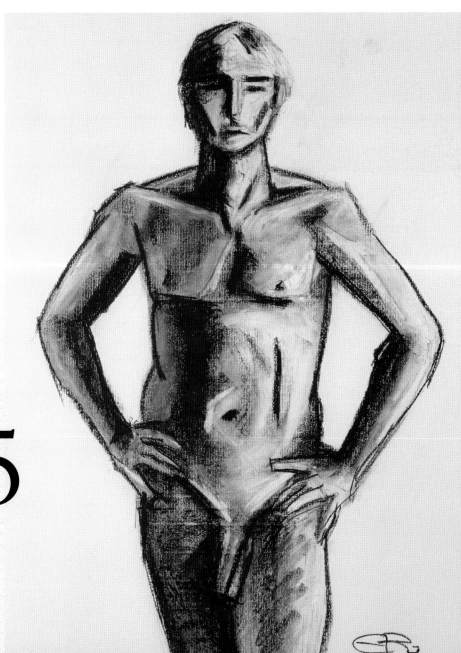

The PROFILE:
The IMPORTANCE of CONTOUR

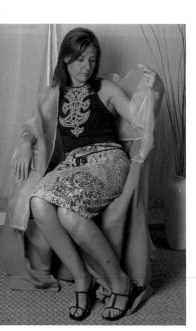

In this step-by-step exercise, we will see at the hand of Marta Bru how to use a black Conté pencil to draw a figure from a strictly linear point of view, with no hatching whatsoever. The characteristics of the line used to define the contour can transmit the naturalness of the form, its materiality, surface texture, and visual charge. To do so, all one must do is control the width and intensity of the line on the paper.

1

2

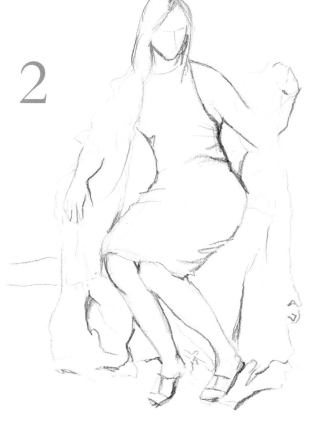

1. As opposed to other exercises, in this case we do not begin the design of the drawing using simple geometric shapes. The right outline is made directly with the line of the pencil, practicing a contour. These initial lines will be very soft, which allows for easy erasure and constant corrections. We must first draw the contours that are essential to understanding and representing the form. We will do whatever possible to use the fewest lines possible. In the preliminary structure, it is important to consider the zigzag form described by the body's posture, as we can see in the sketch above.

2. Based on the previous sketch, we can construct the whole profile of the figure linearly. The trace of the line doesn't have to be continuous or have a uniform intensity. A line can disappear behind a curve or be interrupted by another contour. Although the true drawing of the contour provides a single line value, the representation gains expressiveness when we vary the width of the line.

3. We finish drawing the lines and internal contours that describe the advance or retreat of each part and also the particular character and tactile sensation of the clothing. The interior lines accentuate the expressiveness of the volume and communicate the three-dimensional quality of each form in relief and the quality of the modeling. If we use a modulated line to give the line drawing the effect of volume, we shouldn't forget that the shaded areas will have to be expressed with thick, intense lines, whereas lighter areas will be suggested by tenuous, fine lines.

3

In some line drawings the system used to represent forms recalls a topographic map, with different lines indicating different levels and thus representing the relief of the land.

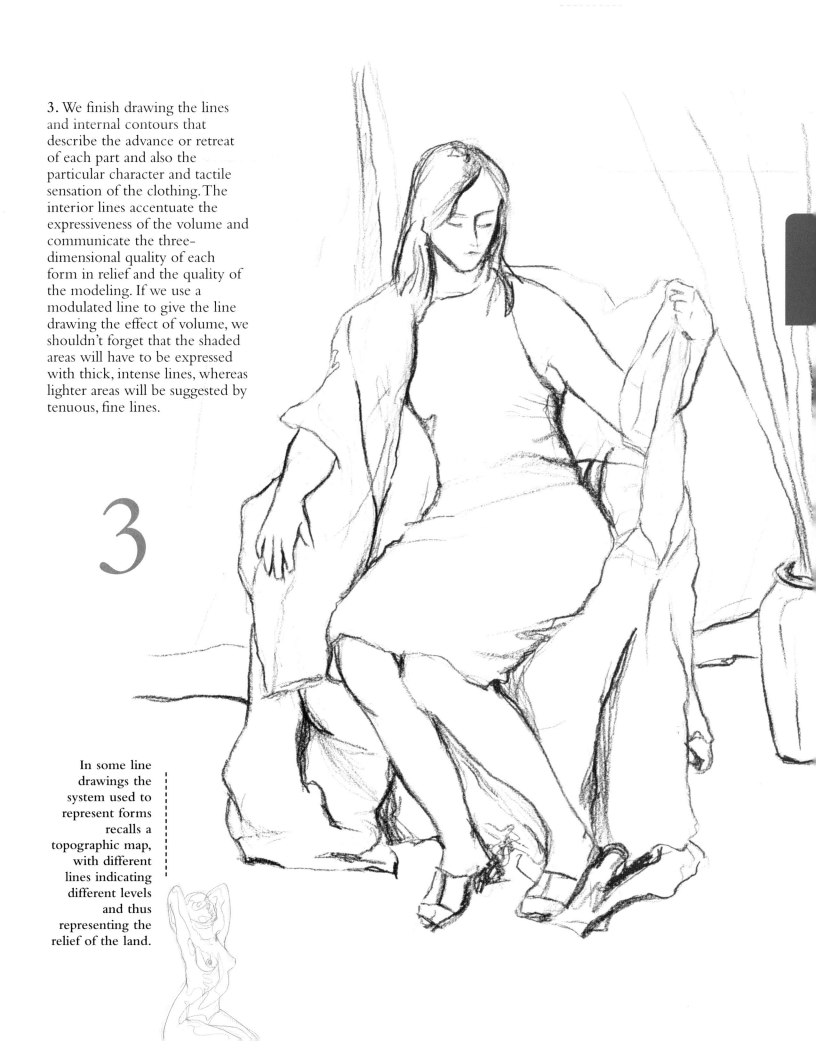

A CLOTHED FIGURE:
FOLDS *and* TEXTURES

In the following step-by-step drawing, Mercedes Gaspar shows us how to draw a clothed figure. Charcoal is one of the preferred media for this exercise, because the combination of lines and tonal gradations that it offers captures the creases and wrinkles in clothing. The drawing of the figure, made on colored paper, is complemented by accents in white chalk to give it a more natural, three-dimensional look.

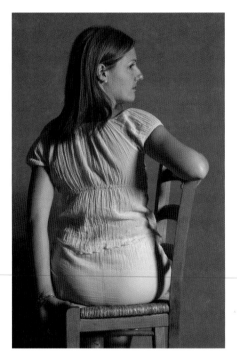

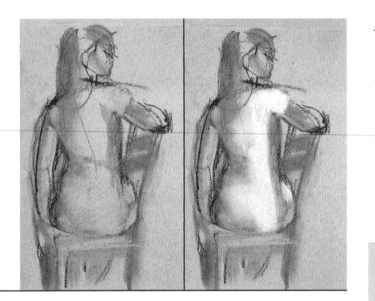

1

2

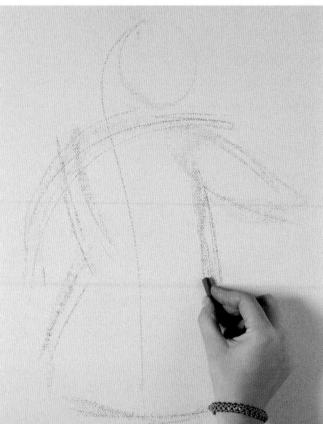

1. First we make a small, preliminary sketch of the model. We begin by drawing the line of the backbone and the oval of the head, and around this structure she will insert the different parts of the body. Then, using the length of a piece of white chalk, we introduce sketchily the lights that give brightness to the model's back.

2. The first lines on the paper should have a strictly constructive function. We draw the line of the backbone and the oval of the head. In a sketchy manner, we resolve the profile of the body and the position of the arms with little more than a curve and an oval. We use the charcoal stick so as not to overdraw, so we can then make corrections easily.

3

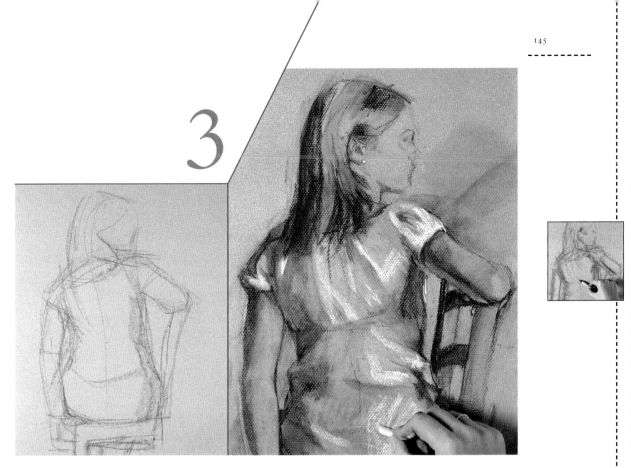

Once the contours are drawn, those that will be accentuated with hatching should be gone over again with the charcoal. We use a tortillon to make these first hatchings and spread the charcoal pigment on the paper. It is enough to rub a slightly dirty tortillon on the less lighted areas.

3. The lines of the outline multiply as we attempt to adjust the sizes of different areas and give proportion to each part of the body. To this end, we have marked the waist line and the creases in the arms. The drawing of the contour should remain open, without connecting the lines completely, so that it leaves the option of rounding out the form by hatching, instead.

We use the flat of the stick, paying attention to the creases of the model's dress. The accents in white chalk complement the previous hatching, highlighting the texture and the volumetric look of the clothing.

4

4. Working in greater detail and using the tip of the white chalk, we render the details of the clothing. Recall that in order to accentuate the texture of the clothing, it is useful to add a light hatching to the accents and thus to clearly distinguish the light area of each wrinkle from its shaded part. The end result is an excellent drawing that alternates smooth blending and somewhat darker, charcoal accents; the whole is nuanced with subtle accents in white chalk.

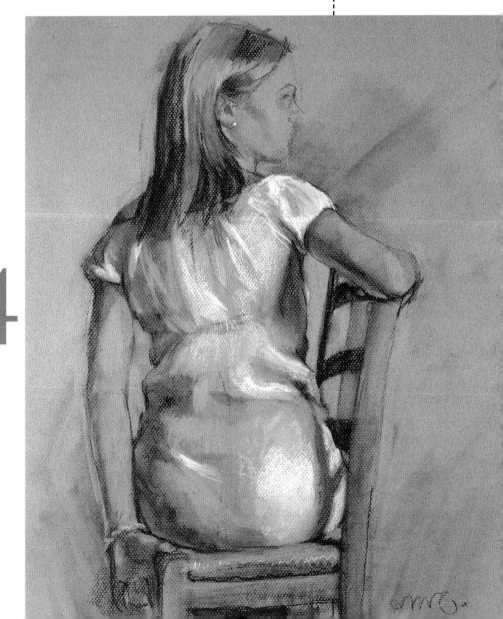

MODELING *the* FIGURE *in* PASTELS *and* CHALK

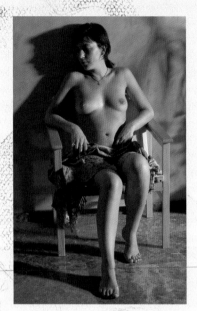

Pastels are usually combined with other drawing media such as chalk or charcoal, to broaden their tonal spectrum. Because of its color, a pastel is much smoother, brighter, and warmer than charcoal. In the present exercise, Marta Bermejo Teixidor shows us how to build the flesh tones of a model from a combination of pastel with maroon and black chalk. These three colors combined with the white of the paper are more than sufficient for making sketches, studies, and works that require a detailed chromatic expression.

1. Just as we have done until now, the outline is the first step in making the drawing, a few general lines in which we group together simple geometric forms that little by little will take shape until they configure the profile of the figure.

2. With small pieces of black chalk and pastels, we reinforce the previous drawing, hatching in the empty spaces that envelop the figure. When we make hatching with pastels or chalk, we will always begin with a light touch and increase the pressure gradually, using the lines of the sketch as a guide.

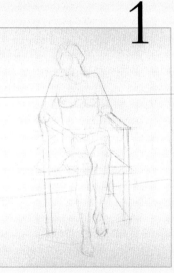

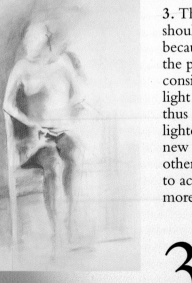

3. These first touches of chalk should be added very carefully, because there is no need to cover the paper without first considering the delicate play of light and shadow on the figure, thus avoiding covering its most lighted areas. We then blend each new addition of chalk into the other colors using our fingertips, to achieve an even tone and a more pictorial effect overall.

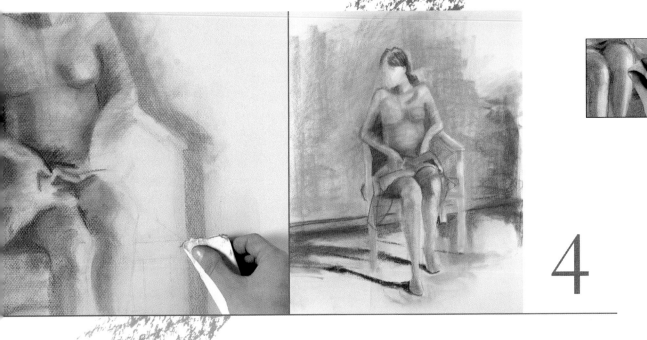

Using an eraser, we open up the shine in the flesh of the figure. During the process of drawing, we have gradually created smooth layers of gray and reddish dust that have darkened the tone of the paper. The accents we make with the eraser heighten the illusion of volume in the figure.

4. As we combine different layers of hatching in black and maroon chalk and pastel, we blend the tones, seeking a volumetric effect. If we blend tones using a cotton rag, we achieve a different effect. The general tone of the blended hatching is darker than when we use a tortillon. Nonetheless, it is these first, blended hatchings that we will use to represent the middle tones. The contrasts of the body should be drawn progressively, finding the tonal values of each plane depending on the light that falls on each one of them.

5. The final effect of volume is achieved with black chalk, which creates the sharpest contrasts between light and shadow in the left-hand profile of the body, and which we use to draw the projected shadows on the floor and wall. The different smooth traces made with the tip of the chalk sketch the facial features and distinguish the profile of the outline of the figure from the background, most visibly in the legs. The end result is a drawing with clear pictorial intensity.

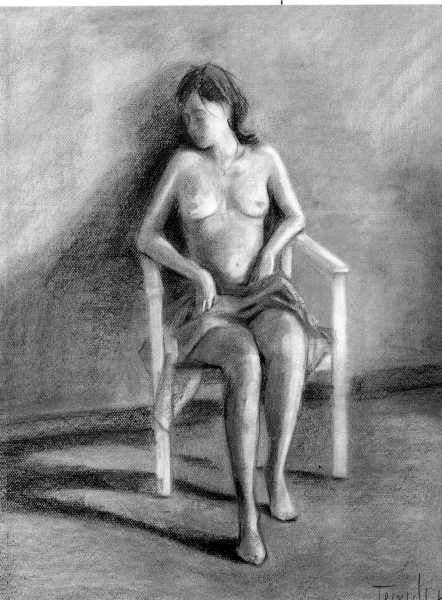

The purposes of a line drawing are many, and they vary depending on the artist: it can be a medium for hatching, modeling, and tonal analysis or have a purely descriptive role. In the following exercise we will see, at the hand of Mercedes Gaspar, how to use a graphite pencil and develop the possibilities of the line, with no smoothing whatsoever, to make a quick sketch of a female nude figure.

LINE DRAWING

of a FIGURE

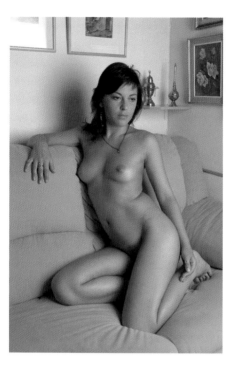

1. The first step is to fix the most significant contours, the lines that best capture the general movement of the figure. In a preliminary study, there is no need to trace a previous sketch—because the sketchy nature of the study makes it unnecessary, although it is helpful to make a mental calculation of the measures and proportions of the figure.

2. Often, the design of the contour and the first modeling lines are simultaneous. They both occur at every moment, so a shaded area or volume can be made solid by simply varying the strokes and suggestion of the contour line.

1

2

3. The general pencil lines are as much a way of expressing volume as they are a general intonation of a base which we can then accentuate in significant places. As we draw we feel for the volume almost by intuition, applying more or less pressure to the pencil. If we grip the pencil fully on the inside of the hand, we can control the direction of the line and keep it from being too intense.

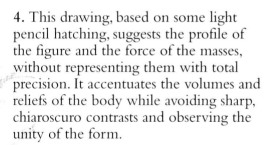

3

4

4. This drawing, based on some light pencil hatching, suggests the profile of the figure and the force of the masses, without representing them with total precision. It accentuates the volumes and reliefs of the body while avoiding sharp, chiaroscuro contrasts and observing the unity of the form.

When an abundance of lines is the dominant feature in our drawings, we should keep the general profiles from getting lost by marking them wherever there is a fold or a very shaded area.

MODELING
FLESH TONES

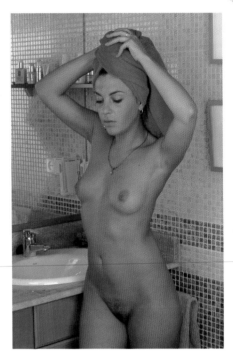

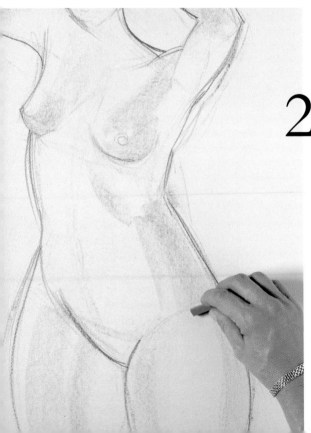

In the nude figure, we encounter all of the problems inherent in representing the flesh, which appears as a fairly uniform surface; its volumes are not evident, but we must grade them nevertheless. The coloring of flesh, which at first glance appears uniform throughout, contains a series of nuances that are hard to appreciate by an eye unaccustomed to the properties of color. The goal is therefore to exercise our eye until we are able to see clearly where the volumes of the body are produced, and to bring them out by using color, just as Esther Olivé de Puig demonstrates in this exercise.

1. We make a sketch using maroon pastel, profiling the contour with a firm, assured stroke. The treatment of the figure is quite free; there is a clear and intentional disproportionally between the top and bottom parts of the body, so rendered to achieve a greater expressiveness.

2. Using the flat of the pastel we apply a light pink tone that will correspond to the middle tones in the drawing. These first stains are made quickly, but with confident motions.

3. The greatest difficulty lies in grading the skin on the basis of colors, because it means we must translate this monochrome surface into more pronounced volumes and forms, based on different chromatic values. It isn't essential to use the color spectrum suggested by the color of the model—rather, we can use colors far removed from the nuances of the skin to create a dynamic work through color contrast.

1

2

3

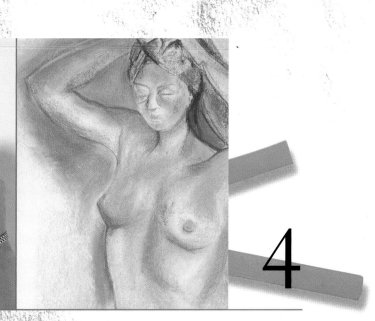

If your fingers are dirty with color and the next step is blending a light color, be sure to clean them off with a rag before you do so.

4. As we gradually cover the figure in color, we begin working on the background. Following the theme of creating a chromatic vibration throughout the work, we make the background yellow. The background color is spread delicately in order to not disrupt the edges of the figure. The right profile of the figure, the lower breasts, and the pubis are underscored with wide swaths of maroon so that some these parts of the figure do not blur into the background. We should grade the figure's tones volumetrically in the same way that we would the curvature of a vase. When coloring where there is shade, the flesh tone becomes darker with the presence of blues and maroons; where there is light, it grow brighter and warmer thanks to the use of oranges, pinks, and yellows.

5. After the hatching process, we sweeten the transitions between tones by smoothing the flesh tones with the pads of our fingers. Then, using the tip of the pastel, we redraw the lines of the face. Once the drawing is finalized, there is a visible chromatic variety in how we suggest the color and quality of the figure's skin, as well as a tonal contrast between the areas with shine and the darkest shadows.

FIGURE *of a* WOMAN *and a* GIRL
On the BEACH

Charcoal is a quick, direct medium. It is also among the most spontaneous, because by nature, it can be used to make wide, undetailed lines. The wide spectrum of possible tones is another one of its attractions. In this demonstration, Mercedes Gaspar makes a composition of two figures with pronounced tonal effects that give a great expressiveness to the drawing. It is necessary to pay attention to the changing directions of the lights, shadows, and reflections on the face and clothing, because these factors describe the volume of the bodies.

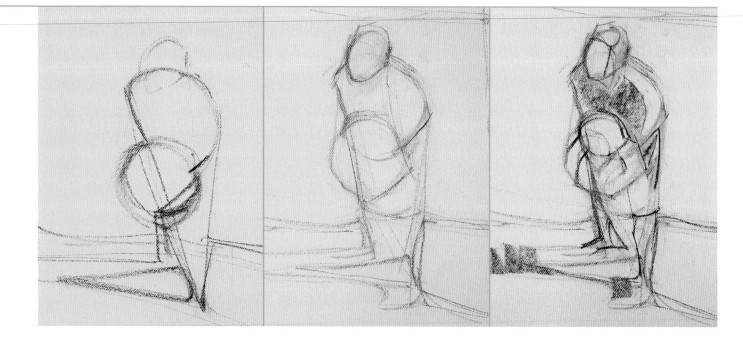

1. To draw the body of the adult figure, we start with an inverted cone; for the head, a circle. For the body of the little girl, we draw a circle and cone on its side to convey the projection of her shadow. We refine on the contour, erasing and doing it over if necessary, until we adjust the initial geometric forms to a preliminary sketch in which we can already begin to see the outline of the adult figure.

Charcoal is the perfect medium for finding the form without working on any of the details. With it, we can stain the paper and trace the guiding outlines of the two figures while comparing the proportions, angles, and inclinations of the body.

2

3

4

We achieved the effects of folds and wrinkles in the woman's dress by adding zigzagging lines, with the point of a charcoal stick, on top of blended shading.

2. Thanks to the sketching we did in the previous step, we were able to establish the profiles of the figures and the linear harmony of their two bodies as a unified whole. The first hatching completes the rounded outline of the form. These first few hatchings, which will be very crude, should be made with a flat charcoal bar.

3. Using thick lines, we cover the background with a soft layer of charcoal, which we then smooth with our fingertips. We accentuate the contrasts of the shadows inside the figure; we can obtain uniform tonal gradations by softening or lightening the hatching with a tortillon. The background tone is an essential reference point for giving greater or lesser intensity to the hatching of the figures.

4. To finish the sketch of the ocean, it is sufficient to add some more intense tones and open some white areas in the crest of the waves. We apply the soft, dense line of the crumbling charcoal in the final stages of the drawing, at the same time as we construct the facial features and the creases in the clothing with slight tonal contrasts. The finished drawing shows a simplified tonal spectrum in which the dark tones form solid masses to unify the image.

INTERIOR *with*
ATMOSPHERIC FIGURE

The rich spectrum of tonal values that can be achieved when a figure is integrated into the atmosphere that surrounds it can be enriched even further using graphite pencils of different hardnesses. Even though Carlant draws this figure in graphite, we might say it has an authentic pictorial effect thanks to the atmosphere created by the grays. With this outlining, its forms are not closed unto themselves, but instead relate to and meld into their surroundings, creating a sense of wholeness and a unified intonation in the drawing.

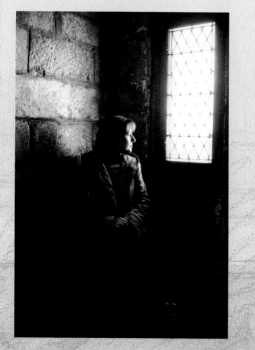

1. The initial lines created with an HB graphite pencil have an orientative character: they first situate the architectural frame around the figure based on perspectival lines: the frame of the window, the angle of the wall, and the stone bench. Onto these initial geometric lines we layer those of the figure in its correct proportions—remember the technique of drawing as if the figure were transparent.

1

2

2. By holding the graphite pencil horizontally, we can quickly create an area with a uniform tone, with no guiding marks; we gradually fill in the main dark areas, disregarding the relief of the forms or the outlines of the figure. The goal is to create a diffuse stain that shows the grain of the paper underneath.

3. A tortillon will help us to eliminate any semblance of lines in the hatching and create smooth transitions between tones.

3

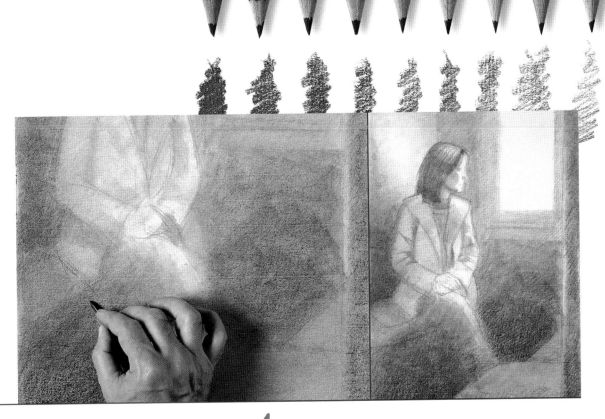

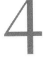

Many artists grow accustomed to using graphite pencils of a single hardness, such as 2B or 4B, and do not exploit the possibilities of using a variety of different grades of graphite within the same drawing. The contrast between the fine lines of a 2H graphite pencil and the dense, black lines of a 6B yields very attractive results.

4

4. Placing the point a soft graphite pencil on its side, we use a rotating motion to gradually darken the interior shadows that contrast with the outline of the figure. Most artists prefer to create the atmosphere of the drawing using the texture of the paper, producing a highly accomplished gamut of tones. In reality, by simply grazing the paper with the tip of the graphite we develop different nuances in the hatching. Using a gradual hatching, we can obtain softly blended tonal effects. It is also possible to soften the tones by rubbing with a fingertip. The spots of light on the face of the figure are achieved by opening up white areas with a soft eraser.

5

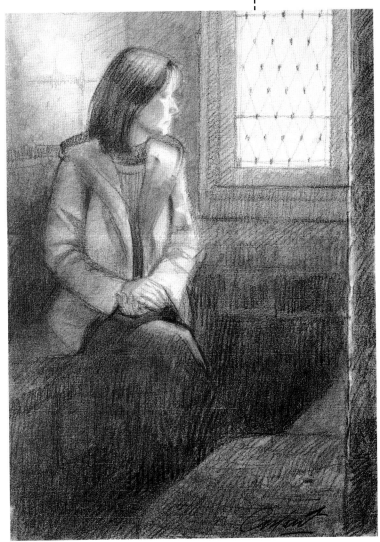

5. A drawing such as this one can be thought of as a sum of overlapping grays, each of which leaves its mark on the paper and makes the next layer smoother and richer; the final marks accentuate the fundamental features of the figure: the texture of the clothing and hair, the lead bars of the window, and the configuration of the hands.

PORTRAIT *of a* FIGURE
in SILVERPOINT

To gain some practice with line and to demonstrate the value of pentimenti in drawing, we will reproduce, at the hand of Carlant and using silverpoint, a female figure holding a dog. This is a method that allows for few corrections, so if any mistakes are made, they must be rectified by adding new lines. To do this exercise we need silverpoint, available at any jewelry store, or we can insert a copper wire in a mechanical pencil. We will select a rigid, fine-grain paper and cover it with a layer of white zinc pigment or gouache. The first layer we apply should be diluted with water; the second should not. Once the paper dries, it is ready to use.

1

1. We begin the compositional study of the model by drawing masses based on simple geometric shapes: an oval for the girl's head, a circle for the head of the dog, and a few more curves and ellipses to describe the location of the other members. After making a geometric outline, we begin our first approach to the forms of the model. This simple compositional and outlining exercise should done on a separate sheet of paper, because silverpoint lines cannot be corrected once they are on the paper.

2. This preliminary study will ensure a more elaborate drawing in which we can clearly distinguish the contours of the figure. If, with other media, the preliminary pencil sketches or outlines are never definitive, when using silverpoint every line we draw is permanent.

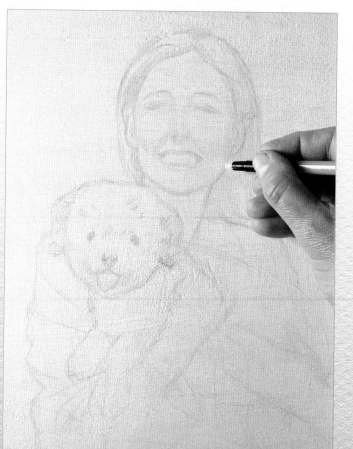

2

3

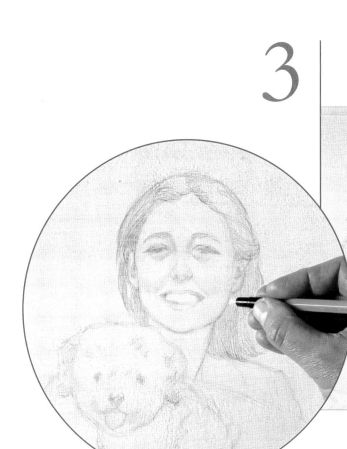

If you wish to accentuate the texture and direction of a strand of hair, take a blade and practice adding overlapping layers of paint. The results will surprise you.

3. Once the preliminary drawing is complete, we gradually shade in the different parts of the drawing, applying stretches of overlapping lines. The sharpened silver lead gives the drawing a very fine, detailed line, perhaps the most delicate of lines possible in any drawing medium. Silverpoint lines can be erased to a point if they are made on an adequate surface, but don't rely on this too much when drawing.

4

4. The progression of dark shades depends exclusively on the pressure we apply to the instrument, because silverpoint doesn't come in different hardnesses or gradations like pencils do. Before finishing, remember that lines made with a silver cutter get darker over time because they rust when they oxidize—when they come into contact with the air—just as silverware does.

Index